OFF THE PEDESTAL

OFF THE PEDESTAL

❧

NEW WOMEN IN THE ART OF
HOMER, CHASE, AND SARGENT

❧

EDITED BY HOLLY PYNE CONNOR

THE NEWARK MUSEUM | NEWARK, NEW JERSEY

AND

RUTGERS UNIVERSITY PRESS | NEW BRUNSWICK, NEW JERSEY, AND LONDON

THE NEWARK MUSEUM

49 Washington Street

Newark, New Jersey 07102-3176

www.NewarkMuseum.org

This book has been published in conjunction with the exhibition *Off the Pedestal: New Women in the Art of Homer, Chase, and Sargent*. Organized by The Newark Museum, the exhibition, as well as the research for the catalogue, have been made possible through major funding by the Henry Luce Foundation, Inc., and JPMorgan Chase Foundation. Generous support for the exhibition was also received from an anonymous donor, the Helen R. Buck Foundation, The Newark Museum Volunteer Organization, and by a grant from the Jockey Hollow Foundation in honor of former Museum trustee Betsy Shirley.

The Newark Museum, a not-for-profit museum of art, science, and education, receives operating support from the City of Newark, the State of New Jersey, the New Jersey State Council on the Arts / Department of State (a Partner Agency of the National Endowment for the Arts), and corporate, foundation, and individual donors. Funds for acquisitions and activities other than operations are provided by members and other contributors.

VENUES:

The Newark Museum, New Jersey:

 March 18–June 18, 2006

Marion Koogler McNay Art Museum, San Antonio, Texas:

 July 26–October 15, 2006

Frick Art and Historical Center in Pittsburgh, Pennsylvania:

 November 4, 2006–January 14, 2007

LIBRARY OF CONGRESS CATALOGING-IN-PUBLICATION DATA

Off the pedestal : new women in the art of Homer, Chase, and Sargent / edited by Holly Pyne Connor.

 p. cm.

Catalog of an exhibition held at the Newark Museum, N.J., Mar. 18–June 18, 2006; at the Marion Koogler McNay Art Museum, San Antonio, TX, July 26–Oct. 15, 2006; and at the Frick Art and Historical Center, Pittsburgh, PA, Nov. 4, 2006–Jan. 14, 2007.

Includes bibliographical references and index.

ISBN-13: 978–0–8135–3696–5 (hardcover : alk. paper)

ISBN-13: 978–0–8135–3697–2 (pbk. : alk. paper)

1. Women in art—Exhibitions. 2. Feminism and art—Exhibitions. 3. Art, American—19th century—Exhibitions. 4. Art, American—20th century—Exhibitions. I. Connor, Holly Pyne, 1952– II. Newark Museum. III. Marion Koogler McNay Art Museum. IV. Frick Art & Historical Center.

N7629.N48N486 2006

704'.042'097309041—dc22 2005011244

A British Cataloging-in-Publication record for this book is available from the British Library.

BOOK DESIGN AND COMPOSITION BY JENNY DOSSIN

Manufactured in China

CONTENTS

ILLUSTRATIONS

FOREWORD

The Newark Museum takes great pride in presenting *Off the Pedestal: New Women in the Art of Homer, Chase, and Sargent*, the first museum exhibition to identify and analyze images of the late nineteenth-century emancipated woman. Given the museum's strong commitment to the display of American art and long history of fostering scholarship in the field, it is particularly appropriate that we have sponsored the research that has resulted in this reevaluation and retrieval of the contemporary context of new women imagery.

Dr. Holly Pyne Connor, Curator of Nineteenth-Century American Art, originated the idea for this project while researching the reinterpretation and reinstallation of the museum's outstanding collection of American art, *Picturing America*, which opened in May of 2001. The final nineteenth-century gallery of this highly acclaimed exhibition is titled "The New Woman" and is dominated by the magnificent *Mrs. Charles Thursby* (fig. 27 and also the cover of this book), a portrait painted by John Singer Sargent in 1897–1898. An iconic interpretation of the New Woman of the 1890s, this striking painting characterizes Mrs. Thursby as assertive, self-confident, and dynamic at a time when the majority of female sitters were presented as maternal, passive, and pure.

The portrait of *Mrs. Charles Thursby* inspired Dr. Connor to begin her investigation of images of late nineteenth-century emancipated women. With the expert advice of Dr. Mary Kate O'Hare, Assistant Curator of American Art and co-curator of the exhibition, she decided to organize the show around defining

characteristics of the new woman type, influenced in part by the period's fascination with labeling and stereotyping. These are the themes of both the exhibition and the essays in this accompanying book.

The exhibition and this publication would not have been possible without the major funding provided at an early stage by the Henry Luce Foundation, Inc., an ardent supporter of American art scholarship and exhibition. In addition, we are most appreciative of the JPMorgan Chase Foundation for its steadfast support of the arts and the major grant provided for this project. Generous support for the exhibition was also received from an anonymous donor, the Helen R. Buck Foundation, The Newark Museum Volunteer Organization, as well as a grant from the Jockey Hollow Foundation in honor of former Museum trustee Betsy Shirley.

Once again, I take great pride in commending the enormously capable staff of The Newark Museum for attending to every detail of this complex, multiyear project. I especially thank Isimeme Omogbai, Chief Operating Officer; Peggy Dougherty, Deputy Director of Development and Membership; Linda Moore, Director of Development; Mark Albin, Deputy Director of Marketing and Public Relations; Tim Wintemberg, Director of Exhibition Design; Rick Randall, Exhibition Designer; Lucy Brotman, Director of Education; Linda Gates Nettleton, Assistant Director of Education; Rebecca Buck, Chief Registrar; Amber Woods Germano, Associate Registrar; and Michael Schumacher, Marketing Communications Manager, as well as their staff members.

We are especially delighted to be able to share this exhibition with the Marion Koogler McNay Art Museum and the Frick Art and Historical Center. Their directors, staff members, and trustees were helpful in attending to the myriad details of this complex, but rewarding undertaking.

Finally, the Trustees of The Newark Museum and I are deeply indebted to the museums, galleries, and private collectors who have generously lent their magnificent works of art, making this exhibition and its subsequent tour possible.

MARY SUE SWEENEY PRICE
Director, The Newark Museum

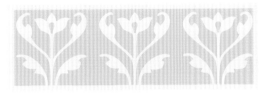

PREFACE

"Here she comes, running, out of prison and off the pedestal: chains off, crown off, halo off, just a live woman."[1] In her description of an emancipated woman, Charlotte Perkins Gilman, the prominent and prolific feminist writer, captures the enormous sense of liberation, exhilaration, and energy that new women experienced as they dramatically redefined the professional and personal expectations for women during the latter half of the nineteenth century. While Gilman felt compelled to chose between her family and her career, other women such as the writer Harriet Beecher Stowe, the activist Elizabeth Cady Stanton, and the painter Lilly Martin Spencer valiantly balanced the demands of their large families with pressing commitments and responsibilities outside the domestic sphere. As members of the first generation of new women, they and others inspired avant-garde artists and writers to create bold, new types of intelligent, active, and independent women. Because the subject of emancipated women was extremely controversial, fine artists infrequently portrayed this type. As a result, locating and securing paintings and sculptures was a particularly formidable task. We are therefore extremely grateful to the public institutions, galleries, and private individuals that so generously lent their powerful images to this exhibition. Without their supportive participation, this project would not have been possible.

A project of this magnitude requires the dedication, hard work, and talent of

numerous individuals. On The Newark Museum's staff, Dr. Mary Kate O'Hare, Assistant Curator of American Art and co-curator of the exhibition, was involved in every aspect of the project. Without her expertise, insight, and extraordinary commitment, *Off the Pedestal* would not have come to fruition. Rick Randall has created a handsome installation that enriches the visitors' experience. Linda Moore's probing questions at an early stage were instrumental in forcing us to conceptualize the project, while Linda Gates Nettleton's focus group provided value assessment of our potential audience's response to the themes of the exhibition. Michael Schumacher's expert editing resulted in focused essays. Rebecca Buck and Amber Woods Germano successfully orchestrated all of the complicated details of the show's tour. Early in this project's history, Ward Mintz, then Deputy Director for Programs and Collections, and Joseph Jacobs, former Curator of American Art, were enormously supportive. I am also deeply grateful to Ellie Berman, who spent innumerable hours in libraries throughout New Jersey and New York locating obscure nineteenth-century articles and publications; to Rebecca Buurma, an intern in the American art department; and to Richard Goodbody, who assisted with photography.

With funds generously donated by the Henry Luce Foundation, Inc., a scholars' meeting was held. Marianne Doezema, the Florence Finch Abbott Director of the Mount Holyoke College Art Museum; Beryl Satter, Associate Professor, Department of History, Rutgers University–Newark; Sarah Burns, Ruth N. Halls Professor of Fine Arts at Indiana University; and David Park Curry, Curator of American Art, Virginia Museum of Fine Art, provided invaluable information at a formative stage of the project, and I am truly indebted to all for their outstanding contribution and their generosity in sharing their considerable expertise.

One of the great pleasures in working on this book has been the opportunity to collaborate with my fellow authors: Sarah Burns and Mary Blanchard. Each has provided an insightful and highly original essay as well as other manifold contributions. They offered ideas, recommended pictures, and provided perceptive suggestions and comments that now inform this book and exhibition.

I am exceptionally grateful to both Leslie Mitchner, Associate Director and Editor in Chief, and Marilyn Campbell, Prepress Department Director, at Rut-

gers University Press, whose practical advice and detailed reading of the text were invaluable while guiding the catalogue to its beautiful conclusion.

Mary Kate and I also want to thank colleagues who generously offered support and advice: Teresa A. Carbone, Linda S. Ferber, and Barbara D. Gallati at the Brooklyn Museum of Art; H. Barbara Weinberg and Thayer Tholles at the Metropolitan Museum of Art; Annette Blaugrund at the National Academy of Design; Katherine Foster at the Philadelphia Museum of Art; Mary Yearwood at the Schomburg Center for Research in Black Culture; Bruce Weber at Berry-Hill Galleries; Kerry Linden at Oneida Community Mansion House; Jean Boyle and Stacy DeMatteo at Rutgers, The State University of New Jersey, Libraries; and Mindy Ellen Moak.

Among the many scholars, associates, and friends who have always taken time to listen to me discuss this favorite project, I would like to express my thanks to Geoff Connor, Ulysses Grant Dietz, Christa Clarke, Matthew Baigell, Sarah Cash, Nonnie Frelinghuysen, Bunny Price, Ken Myers, and Margaret Conrads.

Finally, our Director, Mary Sue Sweeney Price, lent her full support to this project from its inception. She has enthusiastically championed this exhibition and catalogue by consistently providing resources, encouragement, and astute counsel.

HOLLY PYNE CONNOR
Curator of Nineteenth-Century American Art

OFF THE PEDESTAL

NOT AT HOME:
THE
NINETEENTH-CENTURY
NEW WOMAN

ॐ

HOLLY PYNE CONNOR

After the Civil War, a new type of woman emerged in art, literature, and the popular press. Characterized as intelligent, professional, and physically active, these "new women" appear repeatedly in the works of Winslow Homer, William Merritt Chase, John Singer Sargent, and their contemporaries. These innovative artists were fascinated by those who mirrored the dramatic changes in women's lives as they went to college in growing numbers, entered professions previously dominated by men, and claimed greater personal freedoms. Liberated from the confines of home and no longer chaperoned by their families, emancipated women are portrayed riding bicycles, hiking in the mountains, and bathing on deserted beaches. They are shown without male escorts in outdoor public spaces and in clothing that was thought to be improper and mannish. Depicted as professional painters, writers, and performers, women now appear with objects previously identified as male, such as newspapers, whips, and cigarettes. They are also shown in assertive, bold, and even aggressive poses that in previous art had

been seen only in portraits of men, while the age-old symbols of femininity such as flowers, fruits, and infants are replaced by the attributes that came to be associated with new women: bicycles, bloomers, shirtwaists, and tennis rackets. Prior art historical studies have focused on turn-of-the-century portrayals, but the origins of this type date to the late 1860s.[1]

THE POST–CIVIL WAR PERIOD

After the Civil War, emancipated women challenged traditional attitudes about female nature and women's place in society. The expanding economy fueled by the industrial and transportation revolutions, the decline in the male population as a result of the war, and the tireless efforts of the women's movement had a major impact on women's lives, enabling them to enter the workforce in greater numbers than ever before and making new professions available to them. By the end of the century, women dominated such fields as nursing and elementary school teaching, although they were consistently paid less than men were for the same work. New legislation that reformers like Susan B. Anthony, Elizabeth Cady Stanton, and Lucy Stone championed granted women the right to retain their earnings legally and to own property. Higher education became available to middle- and upper-class women for the first time with the founding of women's colleges and the establishment of coeducation in older institutions. Many women gained professional and organizational skills by working for social reforms such as abolition, temperance, the regulation of child labor, and women's suffrage. At the dawn of the twentieth century, three of the five demands of the 1848 Seneca Falls Declaration had begun to be met: most professions tolerated women, education was open to them, and property rights were theirs to some degree. They were still not allowed to vote, however, and they were held to a stricter moral standard than men were.[2]

As women expanded their activities outside the home and demanded greater freedom and opportunity, a virulent backlash ensued. Because some women chose not to marry and have children or to restrict the number of their pregnan-

cies either through contraception or abortion, they were seen as partially responsible for the decrease in the birth rates among urban middle- and upper-class white families during the last quarter of the nineteenth century. At a time when many white Americans were concerned about "racial purity" and the perceived decline of the Anglo-Saxon race, emancipated women were accused of selfishly denying their biological destiny and marital duties. Not only were they perceived as jeopardizing the well-being of the family, but they were also implicated in the pervasive fears about the future of white society. New women were viewed as active participants in race suicide, a term popularized by Theodore Roosevelt to describe the degeneracy of the white race.[3] In his 1897 novel, *What Maisie Knew*, Henry James deals with the disintegration of the nuclear family and the inability and unwillingness of women to care for their children. Maisie's stepfather, Sir Claude, expresses his anger and disgust at emancipated women who reject the domestic role, exclaiming, "Besides, there are no family-women—hanged if there are! None of them want any children—hanged if they do!"[4]

The male medical community also attacked women who aspired to a life outside the home and wanted an education. There was widespread belief that women were governed by their biological natures, centered in their reproductive systems. Respected doctors like Edward Clarke, S. Weir Mitchell, and George Beard promoted the theory that it was dangerous for women to divert their limited energy supply away from their uteruses to their brains by engaging in intense intellectual pursuits.[5] These doctors argued that women who read, wrote, or studied for long periods of time, particularly during menstruation, could become insane or infertile, or produce sickly offspring. Dr. Mitchell's famous treatment for nervous exhaustion or neurasthenia recommended total rest for women that even restricted them from reading and writing.[6] Edith Wharton and Charlotte Perkins Gilman, two prolific writers, were both treated for neurasthenia by Dr. Mitchell and had to endure prolonged periods of inactivity and confinement. In her 1892 short story, "The Yellow Wallpaper," Gilman vividly recounts the anguish of a woman suffering a mental breakdown due in large part to the regime of Dr. Mitchell's rest cure.

For the first time, male physicians began to document cases of lesbian

behavior in their professional journals, describing what they perceived as perverse women who assumed masculine roles, dress, and attitudes. New women were frequently characterized as mannish and linked to lesbianism. The contempt for these women was carried over into the popular press where they were brutally lampooned and satirized. Illustrations proliferated characterizing them as powerful, overbearing, and physically unattractive while a more sinister interpretation vilified them as aggressive, threatening, and decadent.[7]

Nevertheless, by the 1890s, images of new women became prevalent in popular culture and literature. In 1894, the writer Sarah Grand coined the term "New Woman," thereby naming a type that had been evolving for three decades.[8] The New Woman emerged as a recognizable figure, sporting cropped hair and dressed in looser and less restrictive clothing modeled after men's attire. In the 1850s, early feminists such as Stanton and Amelia Bloomer had donned bloomers as a form of protest and as rational dress that was considered a healthy alternative to the tightly laced corset. By the end of the century this garment was heralded as dress reform because it afforded greater movement and comfort.[9] Perhaps the most representative piece of clothing worn by the New Woman of the 1890s was the shirtwaist, an item frequently associated with the Gibson Girl, created by and named after the famous illustrator Charles Dana Gibson (fig. 1). The attractive and charming Gibson Girl came to embody the admirable qualities of the New Woman. She fascinated the nation to such an extent that she became the most popular female image for almost twenty years.[10]

As the ideal Anglo-Saxon woman, the Gibson Girl was a highly reassuring figure that helped to allay the fears of white Americans that foreign immigrants were overrunning the nation. She quickly developed into a symbol of racial purity at a time when there were grave concerns that the country was becoming increasingly diverse. The Gibson Girl had widespread appeal because she simultaneously personified traditional and new aspects of womanhood. Not only was she attractive, chaste, and interested in romance and marriage, but she was also independent, self-confident, and athletic. Like Daisy Miller, the heroine of James's 1878 eponymous novella, the Gibson Girl was "an inscrutable combination of audacity and innocence."[11] While she was characterized as an energetic and

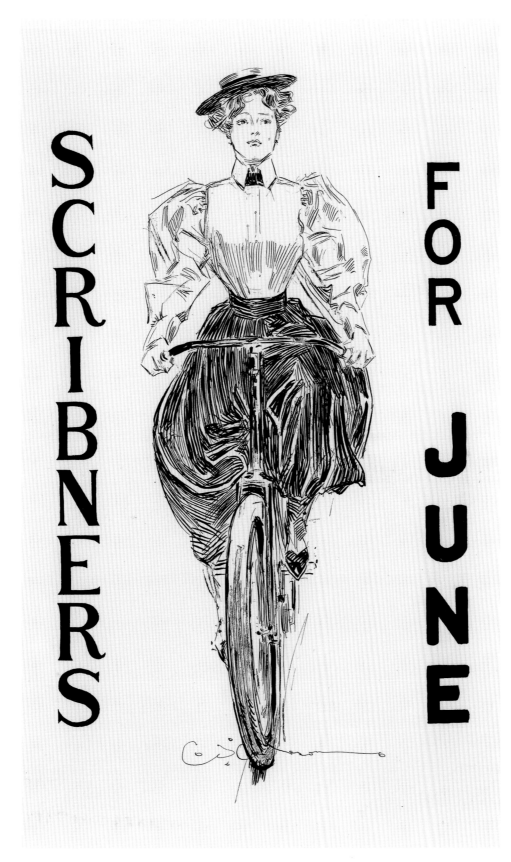

SCRIBNERS FOR JUNE

Fᴵɢ. 1. Charles Dana Gibson, "Scribner's for June," *Scribner's Magazine*,
June 1896. Library of Congress.

free-spirited woman, she still retained girlish qualities that made her acceptable to a mass audience. More importantly, she was not perceived as a real threat either to family values or to masculine authority because the general assumption was that the Gibson Girl would ultimately get married, relinquish her free ways, and become a devoted wife and mother. By the early decades of the twentieth century, the Gibson Girl and variations on her appeared endlessly in the popular press as Gibson, Howard Chandler Christy, and Joseph Christian Leyendecker capitalized on the public's all but insatiable demand for these beautiful but bold girls.[12]

During the last quarter of the nineteenth century, images of emancipated women in paintings and prints were paralleled in literature by the development of a new type of heroine. James, Wharton, William Dean Howells, and Kate Chopin created compelling characters that are portrayed as intelligent, self-confident, and willing to challenge accepted standards of female deportment. However, these strong, memorable heroines frequently died in pathetic circumstances at the end of the story. The authors of new women novels repeatedly rejected the traditional romantic ending in which the heroine marries her true love and lives happily ever after. The early and tragic deaths of these heroines served as a warning that deviant and shocking behavior had grave consequences and warranted severe punishment. Despite the fact that new women were considered forward-looking and often used as symbols of modernity and freedom, many writers were unwilling to provide viable futures for them because their place in society was liminal and contested.[13]

As the debate over new women raged, writers and artists were drawn to complex female figures that highlighted ambivalent attitudes about woman's true nature and place in society. However, in painting and sculpture new women types are relatively rare. Throughout the nineteenth century, the vast majority of fine artists emphasized the purity, passivity, and maternal qualities of the women they depicted, frequently showing them as beautiful wives and mothers in the protected domestic realm. "Her sphere," wrote the influential social historian Thorstein Veblen in his 1899 *The Theory of the Leisure Class*, "is within the household, which she should 'beautify,' and of which she should be

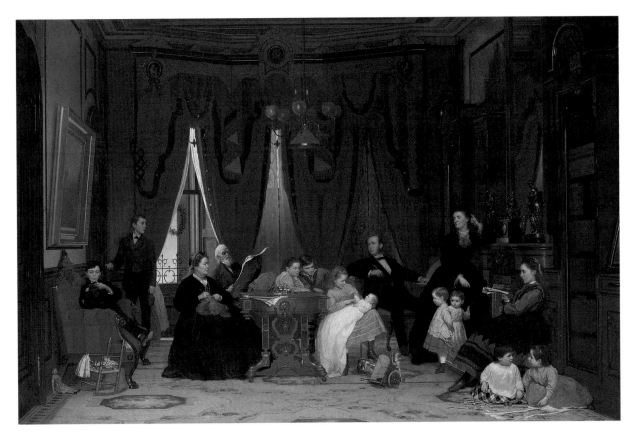

Fig. 2. Eastman Johnson, *The Hatch Family*, 1870–1871, oil on canvas, 48 x 73⅜ in. (121.9 x 186.4 cm). The Metropolitan Museum of Art. Gift of Frederic H. Hatch, 1926 (26.97).

the 'chief ornament.'"[14] In works such as Eastman Johnson's 1870–1871 *The Hatch Family* (fig. 2) where three generations appear, the sitters are portrayed with attributes that reinforce conventional gender roles.[15] The grandfather reads the newspaper, a symbol of worldly knowledge and power, while his son, a wealthy and successful New York financier, is seated with one hand resting on a desk, which in earlier portraiture was almost exclusively associated with male business or literary pursuits. Conversely, the ladies are engaged in womanly activities. The grandmother is shown knitting, an age-old symbol of virtuous industry; Mrs. Hatch stands by a huge mirror, a well-know reference to female adornment and vanity; and one of the daughters prepares for her future role as a devoted mother by cradling an infant in her lap. Only one figure seems to indicate changing expectations; at extreme right a young girl has just looked up from her reading. Perhaps Johnson was making a subtle reference to the new

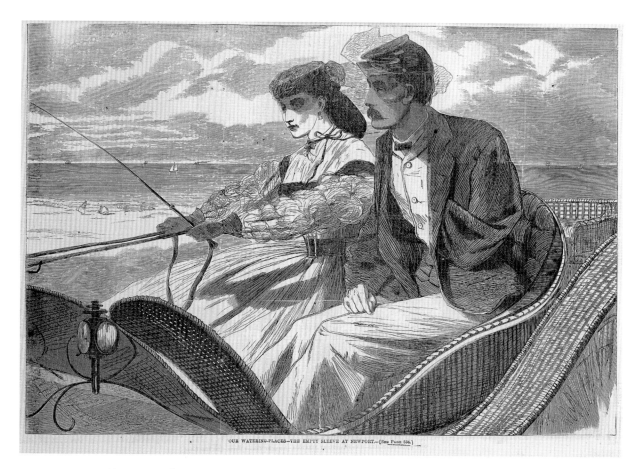

OUR WATERING-PLACES—THE EMPTY SLEEVE AT NEWPORT.—[See Page 534.]

FIG. 3. Winslow Homer, "Our Watering Places—The Empty Sleeve at Newport,"
wood engraving, *Harper's Weekly*, August 26, 1865. Private collection.

thinking woman who was interested in ideas although still within the domestic setting.

Immediately after the Civil War, a few daring artists chose to portray new women types despite the fact that the critical reaction to these images was frequently disparaging. Homer and Lilly Martin Spencer produced powerful works that address the new responsibilities that many women were forced to assume because the men in their lives had died or become disabled. In "Our Watering Places—The Empty Sleeve at Newport" (fig. 3), appearing in *Harper's Weekly* of August 1865, Homer shows a young woman driving a carriage with a disabled Union soldier as her passenger. This woman takes command of the carriage because her companion cannot control the horse. Homer characterizes his female driver as both powerful and attractive. In the story that was written to ac-

company the wood engraving, however, the actions of the woman in the driver's seat are described as being highly questionable. In this brief tale, Captain Harry Ash, the Union soldier, is upset that the woman he loves has learned to drive. "He had, young as he was, old-fashioned prejudices. He liked womanly women. The girls of society, in their *prononcée* toilets, with their loud laughter and bold eyes, and ambition to be fast often shocked him. And this new freak of driving had seemed the worst of all."[16] The story states that the woman's actions were considered "unwomanly" or deviant, proof that conservative society did not approve of forceful women who flaunted their abilities in public. Although Homer portrays a strong yet feminine lady, the text states that she was viewed as unnatural, indicating that new women were highly controversial in the late 1860s when Homer first began to focus on this type. To a twenty-first-century audience, this woman appears totally acceptable, but to Homer's contemporaries, she was interpreted as behaving in a questionable, subversive, and even offensive manner. In fact, as new women continued to challenge accepted female deportment, they often elicited criticism, scorn, and abuse.

Spencer also addressed the profound societal changes brought about by the war. In *The War Spirit at Home; or, Celebrating the Victory at Vicksburg,* 1866 (fig. 4), she portrays a disorderly household and an incompetent mother. Spencer's interior represents a disturbing departure from the orderly and opulent Victorian homes or the cozy country kitchens that appear in the pictures of the period, while the mother and children behave in an alarming manner. The mother, thought to be a self-portrait of the artist, is shown holding the *New York Times* in one hand and awkwardly balancing her hungry infant on her lap. Overwhelmed by her responsibilities, she cannot nurse her baby as she focuses on the paper. This autobiographical image refers to Spencer's dual roles, as the primary breadwinner who supported her family through the sale of her art and as the main nurturing force within the family. During the nineteenth century, newspapers were associated almost exclusively with successful businessmen and men interested in politics, not with wives and mothers. Therefore, Spencer has usurped a symbol of masculine power, prestige, and knowledge and bestowed it upon a woman.

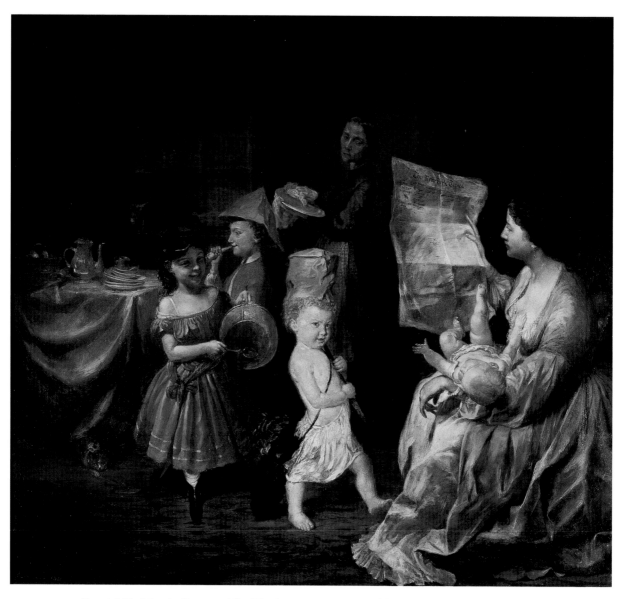

Fig. 4. Lilly Martin Spencer, *The War Spirit at Home; or, Celebrating the Victory at Vicksburg,* 1866, oil on canvas, 30 x 32¾ in. (72.2 x 190.5 cm). The Newark Museum, Purchase 1944 Wallace M. Scudder Bequest Fund 44.177.

A nineteenth-century audience would have been amused, but also shocked at Spencer's portrayal of the children, who are depicted as out of control, rowdy, and half naked because the mother is distracted from attending to their needs. The implication is that the next generation is not being properly raised, a theme that William E. Winner explores humorously in his 1865 genre painting,

FIG. 5. William E. Winner, *Home from School*, 1865, oil on canvas,
29½ x 22 in. (74.9 x 55.8 cm). Courtesy of The Historical Society of
Pennsylvania Collection, Atwater Kent Museum of Philadelphia.

Home from School (fig. 5), where an older woman reads the newspaper while a
naughty and unsupervised boy does a handstand behind her back.[17] Spencer's
painting, however, is even more subversive because the artist shows the young
daughter wearing the cap of a Union soldier, indicating that she has followed
her mother's lead by appropriating a symbol of male power. In *The War Spirit at*

Home, chaos rules and ambiguous gender roles threaten the stability of the family and, by extension, society. Without the support of an adult male, the mother cannot deal with huge responsibilities that have been thrust upon her as a result of the war.[18] The provocative and contested images by Homer, Spencer, and Winner dating from immediately after the Civil War set the stage for the profound changes that occurred in women's lives as their social roles expanded.

UNCHAPERONED WOMEN IN PUBLIC

In the late 1860s, provocative images of women without male chaperones in outdoor public spaces begin to appear for the first time in American art. In these works, women are no longer confined to the domestic sphere or viewed solely in connection to their families, reflecting the freedom that some women had achieved in their personal lives as their boundaries expanded. Indeed, the period after the Civil War marks the emergence of significant numbers of women in the public arena.[19] However, to many Americans at the time, these women were perceived as behaving in an improper and bold manner. They threatened the accepted view that women's proper and only sphere was the home, while their independent attitudes undermined the traditional view that woman were dependent, passive, and vulnerable. "That was the way he like them–not to think too much, not to feel any responsibility for the government of the world," thought Basil Ranson, the chauvinistic hero of James's 1886 novel, *The Bostonians.* "If they would only be private and passive, and have no feeling but for that, and leave publicity to the sex of tougher hide."[20] In James's and Wharton's novels, the heroines who appear in public without proper supervision are the topic of scathing gossip and their reputations are ultimately ruined. Throughout the nineteenth century, women who were seen alone in public ran the risk of being viewed as immoral or, even worse, as prostitutes.[21]

Homer was the first artist not only to focus repeatedly on new women types, but also to show them unchaperoned in public, frequenting such popular locales as mountain retreats and ocean beaches. Homer's bold women are por-

trayed outdoors, participating in recreational activities. These women challenged traditional views of womanhood because they called into question the widely held belief that women were by nature frail and passive; even more controversial was the fact that they defied those medical theories that recommended that females restrict their physical activities in order to preserve their health and fertility.[22]

Mary Cassatt was also drawn to the theme of independent women who like herself defied conventional attitudes about women's proper sphere. Cassatt recalled that 1877 was a pivotal year in her career because this was when Edgar Degas invited her to exhibit with the Impressionists. "At last I could work absolutely independently, without worrying about the possible opinion of a jury."[23] Freed to explore subjects of her own choice, from around 1877 until 1881 she embarked on a series of paintings of new women. In these works, she frequently employed her mother and sister, Lydia, as models. In *A Woman and Girl Driving* of 1881 (fig. 6), Lydia is shown in control of the family carriage accompanied by Degas's niece and Mathieu, a family servant. At the very center of the composition, Lydia's hands appear firmly grasping the reins and holding a whip, an object associated with male power and dominance. Like Spencer, Cassatt is being intentionally subversive by showing a woman with an object that previously had appeared only in the hands of men. But, unlike the mother in *The War Spirit at Home,* who has lost control of her children and her household, Lydia is clearly in charge, calmly directing the carriage. The only male figure in the work is Mathieu, who appears featureless in *profil perdu,* marginalized on the right side of the composition. Spencer and Cassatt, two serious, professional artists, dared to show women in positions of authority.

While Cassatt situated Lydia in a Paris park, the Bois de Boulogne, Chase painted his new women in the urban parks of Manhattan and Brooklyn. Chase focused on this theme in the late 1880s and early 1890s, producing numerous images of women outdoors without male escorts. Chase's solitary women appear on park benches and paths, rowing on lakes, and looking into the water from a dock. Frequently, these women gaze directly at the viewer, acknowledging the fact that they are being watched. In this regard, they differ from Homer's and Cassatt's women, who are unaware of the viewer and totally absorbed in

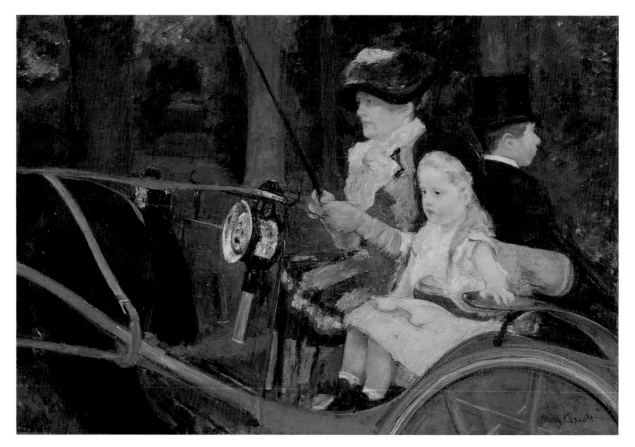

FɪG. 6. Mary Cassatt, *A Woman and Girl Driving,* 1881, oil on canvas, 35⁵⁄₁₆ x 51⅜ in. (89.7 x
130.5 cm). Philadelphia Museum of Art, Purchased with the W. P. Wilstach Fund, 1921.

Fig. 7. William Merritt Chase, *In the Nursery,* 1890, oil on panel, 14.38 x 16 in. (36.5 x 40.6 cm). Private collection.

their activities. Chase's women, on the other hand, engage the viewer, but as Barbara Gallati has noted, their expressions are inscrutable.[24] Works such as *In the Nursery* of 1890 (fig. 7) are highly ambiguous images in which Chase thwarts a simple reading of the painting. Dressed in white, a color associated with purity and innocence, and holding flowers, one of the most well-known symbols of femininity, a young woman hunches in a chair with her elbows on her legs. Her pose is highly undignified because during the late nineteenth century, a lady in public was supposed to sit in an upright and rigid position. Even more shocking is her bold gaze directed toward the viewer. Women in public were warned against having eye contact with strangers because this action might result in an embarrassing exchange or, even worse, a misunderstanding that the woman

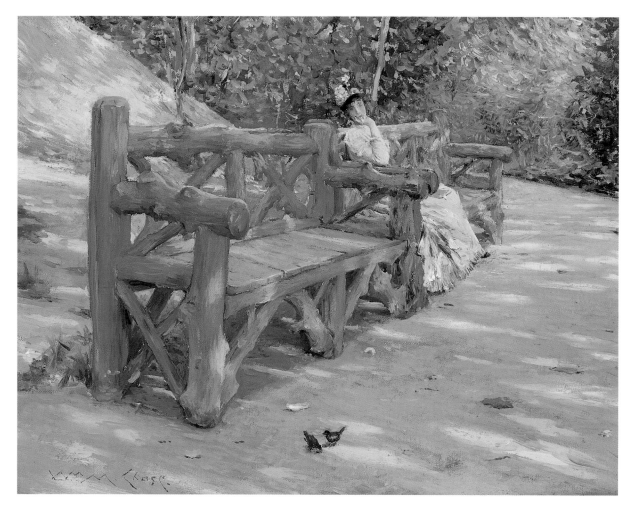

FIG. 8. William Merritt Chase, *Park Bench (An Idle Hour in the Park—Central Park)*,
ca. 1890, oil on canvas, 12 x 16 in. (30.48 x 40.64 cm).
Museum of Fine Arts, Boston, Gift of Arthur Wiesenberger, 49.1790.

was a prostitute soliciting a male customer. Chase adds yet another layer of ambiguity with his title, *In the Nursery,* that may be ironic because the woman, dressed in virginal white and holding flowers, is not in her child's nursery, but in a public setting. Furthermore, she is not characterized as a mother and her reason for being in this secluded and remote area of Central Park is a mystery. Clearly she represents a different kind of woman from the devoted mothers tending their young children who appear with such regularity in Chase's other paintings of New York City parks.

In *Park Bench* (probably *An Idle Hour in the Park—Central Park*), ca. 1890 (fig.

8), Chase returned to the theme of a young woman alone in a park setting. Like all of the new women he painted, this figure's facial expression is ambiguous, although her pose, with her head resting in her hand, is associated with the thinking woman. The small book in her lap indicates that she has been reading; its yellow cover implies that she is enjoying one of the romantic and risqué French novels of the period.[25] Seated on a huge rusticated bench that appears to engulf her slight frame, she stares directly at the viewer, acknowledging that she is being watched. This was a bold action during a period when women in public were not supposed to interact with strangers. Like Homer's female riders, hikers, and bathers, she defies conventional behavior in order to enjoy the outdoors without male protection. In this regard, she brings to mind James's Daisy Miller, who willfully ventures out in public alone. Daisy repeatedly refuses to heed the warnings she receives about her improper behavior and is eventually shunned by polite society. Throughout the novella, her independent and wild manners are observed and criticized. Although the narrator, Winterbourne, is initially attracted to the beautiful, engaging, and innocent Daisy, his interest wanes because her actions seem to indicate that she is immoral. Winterbourne misjudges Daisy's true nature, but she offends his rigid and extremely proper sensibilities to such an extent that he ultimately rejects her. In the 1880s, a young girl like Daisy, who behaved in an independent and free manner, was labeled "advanced," but by the next decade she was referred to as "new."[26]

THINKING WOMEN

Among the defining characteristics of advanced and new women were their intelligence, their interest in books, and their desire to be educated. During the last quarter of the nineteenth century, artists began to depict women in the act of reading. When this imagery was first introduced, it had controversial implications because of the ongoing debate over women's access to education and because of the widely held belief that women were incapable of higher thought and reasoning. Since women have smaller brains than men, they have frequently

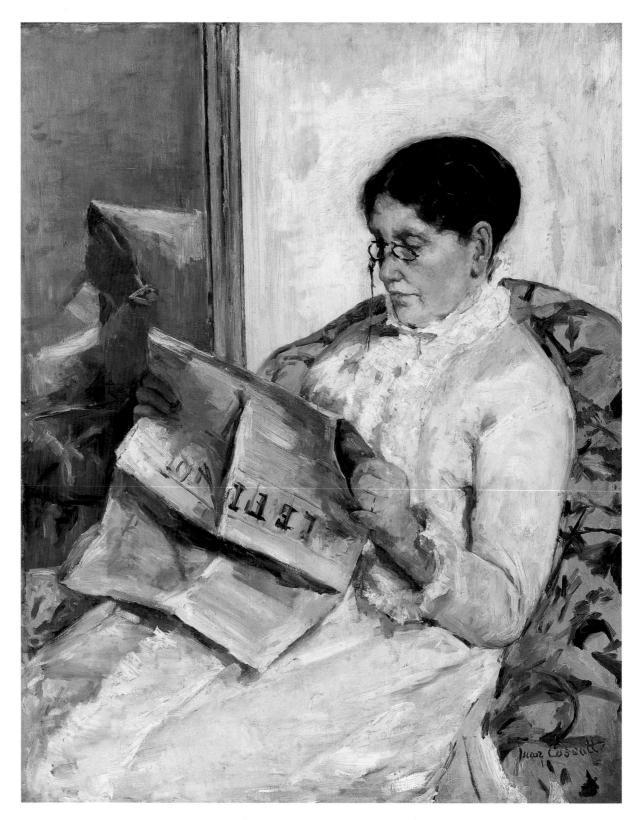

FIG. 9. Mary Cassatt, *Reading "Le Figaro,"* ca. 1877–1878, oil on canvas, 41 x 33 in. (104.14 x 83.82 cm). Private collection, Washington, D.C.

been viewed as intuitive and emotional while men have been credited with intelligence and genius. As the respected British psychiatrist Henry Campbell stated in 1891, "Genius of the highest order is practically limited to the male sex."[27] Male doctors argued that if women engaged in intense intellectual pursuits, they could become ill. Dr. Edward H. Clarke warned that studying for more than a few hours a day could be dangerous, citing numerous examples in his widely read *Sex in Education* (1873) of young women who had ruined their health at college. "She persisted in getting her education," Clarke wrote, "and graduated at nineteen, the first scholar, and an invalid."[28] As many women went to college and a few entered professions like medicine and law, however, there was greater recognition and acceptance of women as rational and thinking individuals capable of advanced reasoning.

For the first time in American art, women are portrayed as bright, thoughtful, and mentally engaged in their reading. Previously, women had been depicted passively holding Bibles, books, or papers, indicating primarily that they were literate and pious. During the last quarter of the nineteenth century, a new iconography develops that highlights female intelligence.[29] In the art of Spencer, Cassatt, and Eastman Johnson, women are defined in a new manner characterized by their ability and desire to use their minds. These artists defied previous pictorial conventions by showing women reading newspapers in order to emphasize the fact that women wanted to be informed. In *Reading "Le Figaro"* of 1878 (fig. 9), Cassatt depicts her mother with a copy of the Parisian paper.[30] By emphasizing the nexus of head, hand, and paper, Cassatt underscores the intelligence and total absorption of the sitter. The artist presents her mother as a middle-aged woman with glasses perched on her nose, who is inquisitive and interested in current events. Works such as these indicate that women were no longer restricted to the domestic sphere mentally; their boundaries were expanding to encompass the world outside the home.[31]

When male artists show women holding newspapers and reading, their interpretations tend to be more conventional than those of their female colleagues. In Johnson's *Interesting News* of 1872 (private collection), for example, an attractive young woman is shown reading the newspaper. While the title of

the painting, the map on the wall, and the paper refer to the outside world, Johnson also focuses on the comfort and security of home. Unlike Cassatt, who dramatically crops the body of her middle-aged mother, placing it close to the picture plane in order to emphasize the mental act of reading, Johnson revels in the sensuousness of his sitter, who is shown reclining with a voluptuous body, lovely face, and exposed foot. With her head next to a vase of flowers, the traditional emblem of femininity, the beautiful young woman turns her back to the window, a well-known symbol of freedom from the domestic sphere. Indeed, Johnson's thinking woman appears at home in a cozy interior reminiscent of seventeenth-century Dutch genre painting.

Homer also painted women reading in relaxed poses, absorbed in their books or novels, in a number of his sumptuously colored oils and watercolors. While the sheer beauty of the women and their settings is a major theme of these works, they are also a serious expression of the intellectual capabilities of women. Perhaps Homer's most powerful and politically charged interpretation of a woman reading is his 1877 *Sunday Morning in Virginia* (fig. 10) where a young African American girl, with a large Bible on her lap, instructs a group of younger children.[32] Although clearly related to Homer's series of new woman schoolteachers, the young reader in *Sunday Morning in Virginia* is a more complex and ambiguous figure, embodying issues of race as well as gender. Before the Civil War, slaves were not permitted to learn how to read or write, but during Reconstruction these restrictions were lifted. In this work, Homer presents different levels of learning and comprehension. The young girl is thoroughly literate and capable of teaching others while the boy to her left is eager to learn, suggested by his concentration on the text. Physically isolated from the group huddled around the young teacher, the oldest figure, a woman, is portrayed as mentally disengaged, unable either to read or to understand the lesson. This figure seems to represent an older generation of African Americans who had been denied an education.

By the 1890s, depictions of thinking women, shown with the latest books or novels, had become a staple of the popular press. Dressed in academic gowns or tailored shirtwaists, they are depicted on the campuses of the newly founded women's colleges such as Mount Holyoke (1837), Wheaton (1860), Vassar

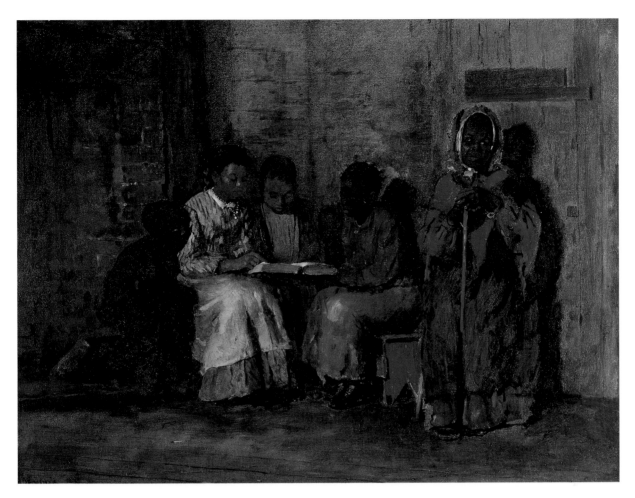

FIG. 10. Winslow Homer, *Sunday Morning in Virginia*, 1877, oil on canvas, 18 x 24 in. (45.71 x 60.96 cm). Cincinnati Art Museum, John J. Emery Fund.

(1865), Wellesley (1870), and Smith (1876). In C. Allan Gilbert's poster for *Scribner's Monthly Magazine* of May 1898 (fig. 11), a number of emancipated women are shown at Wellesley. In the foreground are three monumental figures that epitomize the New Woman of the 1890s. The first is shown in the classic pose of the dynamic woman with one hand on her hip, holding an open book. The second appears with two golf clubs, a reminder that women now played recreational sports, while the third holds a bicycle, the vehicle that would come to define the New Woman. This poster celebrates the intelligent, educated, and active females who had gained acceptance as role models for a new generation of women who were demanding a college education. At the turn of the century,

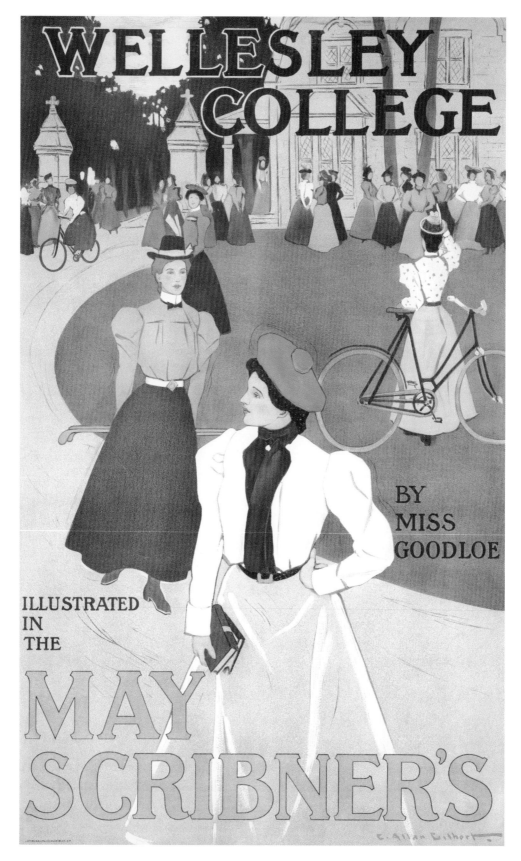

Fig. 11. C. Allan Gilbert, Poster for *Scribner's Monthly Magazine*, May 1898.
Solton and Julia Engel Collection, Rare Book and Manuscript Library, Columbia University.

images of the New Woman were widespread in posters and advertisements for such products as bicycles, novels, and typewriters. These advertisements targeted the growing number of female shoppers who had become an economic force and who clearly identified with the images of self-confident, bright, and healthy women that were used to promote feminine products and accessories.[33]

PROFESSIONAL WOMEN

Armed with an education, women embarked on careers, becoming teachers, nurses, painters, performers, and even medical doctors, lawyers, and businesswomen.[34] Among the more welcoming professions, art drew and accepted large numbers. Women flooded the painting academies to such an extent that the art historian Kirsten Swinth notes they actually outnumbered the male students by the 1880s, while nearly half of the practicing artists counted in the 1890 census were female.[35] Women openly competed with their male colleagues by publicly exhibiting their works and receiving distinguished awards and commissions. Yet few of them were accepted at the more established institutions; throughout the nineteenth century, only seventeen women were elected to full membership of the prestigious National Academy of Design and none were admitted to the elite Century Club.[36]

Alice Barber Stephens's *The Women's Life Class* of 1879 (fig. 12) records students painting from a nude female model at the Pennsylvania Academy of the Fine Arts. In 1868, the Academy was the first institution to offer life classes to female students; however, women had restrictions imposed upon them. They were separated from the men's classes because it was not considered proper for both sexes to look at a nude model together and they were not allowed to the study the naked male body. In this picture, Susan Hannah Macdowell, a talented young artist who was also a fellow student of Stephens, is shown hard at work with her shirtsleeves rolled up. The close grouping of student, model, easel, and paint box documents the classroom environment where eager pupils learned the rudiments of their craft.[37] Macdowell was a serious artist who won numer-

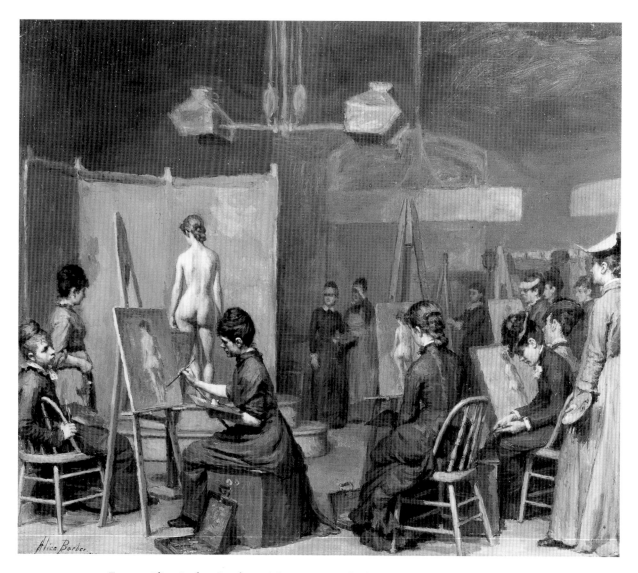

FIG. 12. Alice Barber Stephens, *The Women's Life Class.* ca. 1879, oil on cardboard,
12 x 14 in. (30.5 x 35.6 cm). Courtesy of the Pennsylvania Academy of
the Fine Arts, Philadelphia. Gift of the Artist.

ous awards, but after her 1884 marriage to her teacher Thomas Eakins, she cur-
tailed her career in order to devote her life more fully to her husband and his
work, a common practice at the time.

In fact, the female artist was an extremely popular subject in the paintings,
prints, and novels of the period. Howells particularly was fascinated by her, creat-
ing memorable characters such as Cornelia Saunders, the heroine of his 1893
novel *The Coast of Bohemia,* and the beautiful and talented Alma Leighton of *A*

Hazard of New Fortunes (1890). Alma, like so many of the emancipated women of her generation, chooses not to marry because she wants to pursue her career, stating, "I'm wedded to my art, and I'm not going to commit bigamy."[38] Many professional women never married, realizing the difficulties involved in balancing a career and a family. Cassatt, Cecilia Beaux, Elizabeth Nourse, Elizabeth Coffin, and Ellen Day Hale, all successful and highly trained painters, remained single.

In their self-portraits, these accomplished artists frequently asserted their professional status by depicting themselves in their studios. Nourse who, like Cassatt, spent almost her entire working career in France, depicted herself in the act of painting in her 1892 *Self Portrait* (fig. 13). Unlike the female miniature and still life painters of previous generations who worked in watercolors on a small scale, she presents herself with oil brushes and palette beside a huge canvas, indicating her grand conception and exalted ambitions. A strong light brilliantly illuminates her face and her large, broad forehead, a facial feature associated with intelligence throughout the nineteenth century. Dressed in a work apron, Nourse looks at the viewer with a penetrating and challenging gaze that attests to her keen and inquiring intellect. The rich, somber colors of the composition are relieved by the lighted areas of the face and the raw edge of the canvas. Through the use of this luminous color, Nourse links her head, the source of her creativity, to her work of art, the unseen picture.[39]

When Coffin painted what is probably her self-portrait (fig. 14), she also depicted an artist with palette and brushes who appears in a studio with a massive canvas.[40] By including a girl who acts as model and muse, she creates an underlying narrative dealing with the act of creation. While the model stands, brightly illuminated in a dazzling white dress, the artist appears seated, dressed in somber colors. Shown in *profil perdu,* Coffin's head is dramatically silhouetted against her canvas in such a way that she and her art appear intimately connected. By choosing to obscure the distinctive facial features of the artist, she transcends the personal. Following a long tradition in art, she presents the act of painting as both a manual and mental activity. The canvas, palette, and brushes, representing the tools of the trade, are essential to the production of art, but the artist's imagination, inspiration, and intense concentration are paramount, implied by the promi-

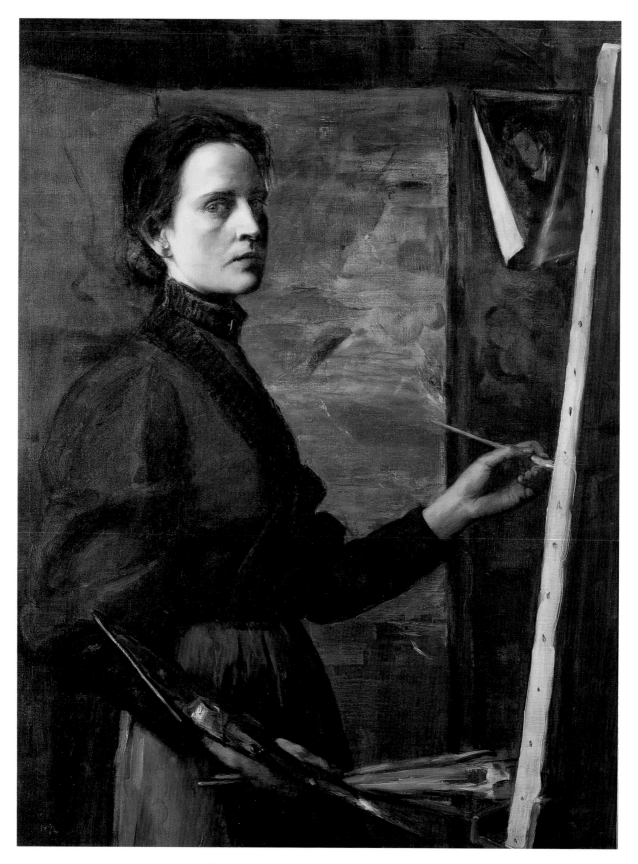

FIG. 13. Elizabeth Nourse, *Self Portrait*, 1892, oil on canvas,
39 x 29 ½ in. (99.1 x 75 cm). Private collection, Florida.

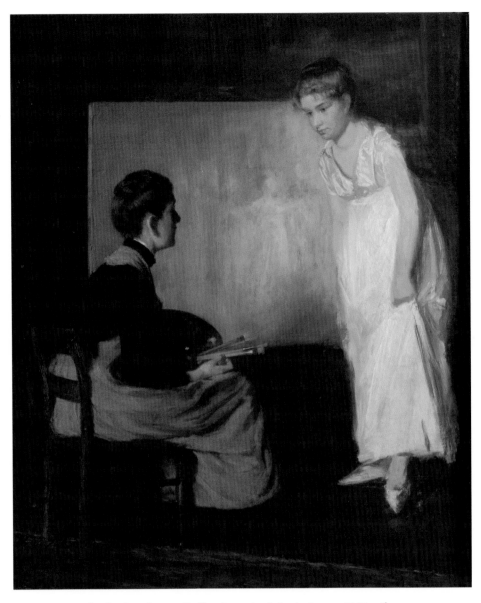

Fig. 14. Elizabeth Rebecca Coffin, *Portrait of the Artist,* ca. 1890, oil on canvas, 29 x 24¾ in. (73.66 x 62.86 cm). Nantucket Historical Association, gift of the Friends of the Nantucket Historical Association, 98.65.1.

nence given to the head of the artist silhouetted again the blank canvas. Painter and model bend toward each other in a silent, but profound communion. Between them appears the figure on the canvas, the product of their fruitful collaboration.

The self-portraits of Nourse and Coffin are highly personal statements about artistic inspiration and expression. In both, women are shown as dedi-

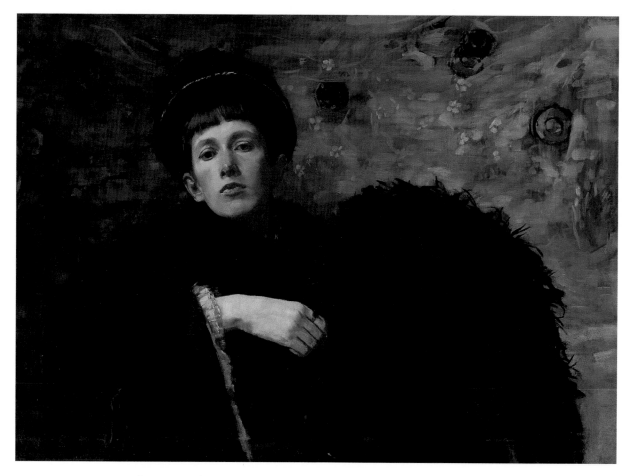

FIG. 15. Ellen Day Hale, *Self Portrait*, 1885, oil on canvas, 28½ x 39 in. (72.39 x 99.06 cm).
Museum of Fine Arts, Boston, Gift of Nancy Hale Bowers 1986.645.

cated, serious, and thoughtful professionals whose large canvases and oil paints announce their willingness to tackle complicated compositions in a medium that women in the past had been discouraged from using.

In Hale's riveting 1885 *Self Portrait* (fig. 15),on the other hand, there is no overt reference to her profession, but rather the artist presents herself as an emancipated woman whose short bangs frame her face. In the late nineteenth century, women cut their hair as an act of independent and defiance. Hale presents herself with boyish features that heighten the androgynous quality of her visage with its exposed ears and lack of lipstick or rouge. By prominently placing her large and attenuated hand in the foreground of the composition, Hale may be subtly referencing the fact that this beautiful work of art is a product of her manual as well as mental exertions.

The woman writer was also a subject favored by painters. In 1876, Edward Lamson Henry depicted his friend Lucy Hooper in the study of her Parisian home (fig. 16). Henry draws attention to Hooper's profession as an art critic by placing the sitter next to her desk cluttered with letters and writing material. Holding a newspaper and surrounded by other journals, she is shown with attributes that traditionally appear in male portraits. In contrast to the female readers by Cassatt and Homer, Hooper is not shown concentrating on the content of the morning journal, but rather she smiles warmly at the viewer with an expression of welcome and recognition. Situated in a cozy, domestic setting reminiscent of seventeenth-century Dutch genre painting, she becomes associated with other women writers of the day who pursued their careers from the privacy, security, and sometimes anonymity of their homes.

A remarkably similar work shows the historian Martha J. Lamb in the study of her New York City apartment (fig. 17). Painted in 1878, the year after the publication of the first of her highly acclaimed two-volume *History of the City of New York: Its Origin, Rise, and Progress,* this portrait focuses on the sitter's literary and artistic interests by placing her in an interior filled with books, paintings, and sculpture.[41] Previously in American art, the library was a male preserve where women rarely if ever appeared. However, Lamb is depicted sitting self-confidently in the center of her study grasping a bundle of letters. These letters,

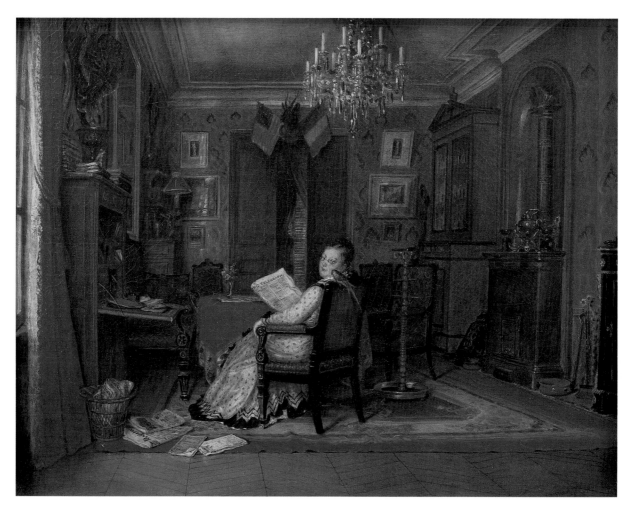

Fig. 16. Edward Lamson Henry, *Lucy Hooper in Her Living Room in Paris*, 1876, oil on canvas, 12½ x 15½ in. (31.74 x 39.37 cm). The Newark Museum, Purchase 1959 Wallace M. Scudder Bequest Fund 59.375.

the massive bookcases that line the walls, and the well-worn volumes on her desk emphasize her scholarly pursuits. As a published author, Lamb wanted to highlight her recent literary accomplishments by commissioning a portrait of herself that underscored her intellectual life. Selecting a female artist to record her likeness, she probably collaborated closely with Cornelia Adele Fassett to create this portrait of a well-read and cultured woman. Characterized as professionals whose domestic environment is filled with references to their work, both Hooper and Lamb wrote in the privacy of their homes. By remaining in the domestic realm, female writers were able to have successful careers without chal-

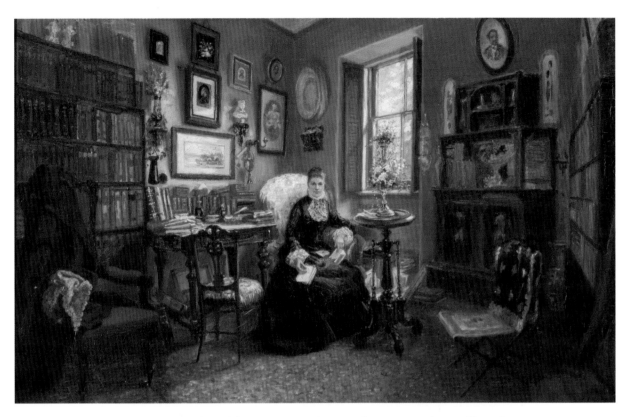

Fig. 17. Cornelia Adele Fassett, *Martha J. Lamb*, ca. 1878, oil on millboard,
15¼ x 24½ in. (38.73 x 62.22 cm). Collection of The New-York Historical Society,
Bequest of Mrs. Charles A. Lamb 1893.2.

lenging the pervasive attitude that women should not venture into the public business arena. Throughout the nineteenth century, women excelled as authors, receiving recognition and financial rewards for their work.

When women broke new ground, they were often careful to present themselves as ladylike, subservient, and virtuous so that they appeared less threatening to the status quo. Sarah Josepha Hale, the powerful editor of the popular magazine *Godey's Lady's Book,* justified her need to work by the fact that she was a widow who had to support her large family. Throughout her thirty years at *Godey's,* she dressed in black mourning clothes as a reminder that she did not have a husband to support her.[42] In fact, emancipated women were so controversial that artist and patron rarely conspired to challenge artistic formulas by

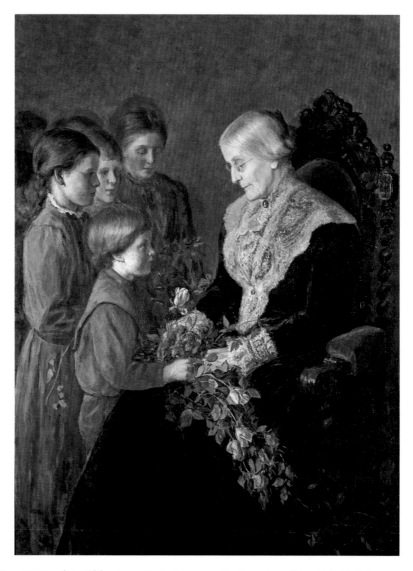

Fig. 18. Sarah J. Eddy, *Susan B. Anthony, on the Occasion of her 80th Birthday*, 1900,
oil on canvas. Smithsonian Institution, Washington, D.C.,
National Museum of American History, Division of Political History.

presenting a female sitter as a new woman. In the majority of nineteenth-
century female portraits, the beauty and maternal qualities of the sitters are em-
phasized, thereby conforming to earlier artistic conventions. Shown in demure,
restrained, and languid poses, women are usually depicted with their families, in
garden settings, or in protected interiors. Sarah J. Eddy's 1900 portrait of the
great reformer Susan B. Anthony (fig. 18) is a fascinating example of how en-
trenched and codified the formula for female portraits had become. Painted on

the occasion of Anthony's eightieth birthday, this work shows the tireless advocate for women's rights accepting a bouquet of flowers from a group of children. No reference to her years of writing, lecturing, and lobbying for women's emancipation and equality are included, but rather Anthony is cast in the traditional maternal role despite the fact that she never married or had children.

BACKLASH

Successful, intelligent, and powerful women were seen as a threat to male authority. As women entered the workforce in increasing numbers and assumed professions previously monopolized by men, a backlash occurred that questioned the morality and the very gender of these women. Veblen criticized women who wanted a life outside the domestic sphere, writing "It is unfeminine in her [woman] to aspire to a self-directing, self-centered life; and our common sense tells us that her direct participation in the affairs of the community, civic or industrial, is a menace to that social order."[43] Quotations such as this document the pervasive late nineteenth-century fear that women's increasing participation in public life would lead to a disruption and perversion of the accepted social order as well as an erosion of male power. Serious concerns were raised about the reversal of gender roles whereby women would behave and become more like men and men would become increasingly effeminate. For many, the manly woman and her decadent male counterpart, the "invert," were responsible for a decline of western civilization. These prejudices drew upon the popular theories of the social Darwinist Herbert Spencer, who argued that the most advanced civilizations were marked by an increasing divergence between the sexes.[44] Some worried that the "masculine" air of manly women threatened this natural divergence, and hence western civilization itself.

Evidence of this backlash in visual form is seen in a new female type that appeared almost exclusively in the popular press. Illustrators and photographers created the highly contested image of the perverse and manly woman. Interpretations range from humorous prints showing women dressed in men's clothing,

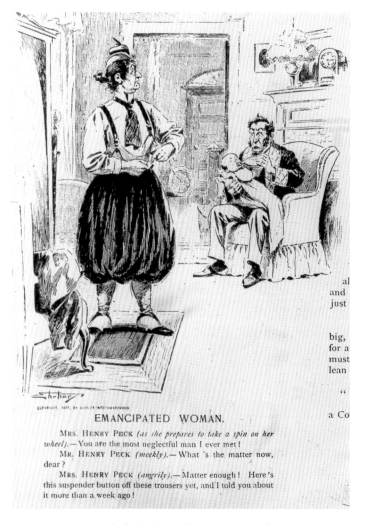

EMANCIPATED WOMAN.

MRS. HENRY PECK (as she prepares to take a spin on her wheel).— You are the most neglectful man I ever met!

MR. HENRY PECK (meekly).— What 's the matter now, dear?

MRS. HENRY PECK (angrily).— Matter enough! Here's this suspender button off these trousers yet, and I told you about it more than a week ago!

FIG. 19. Samuel Ehrhardt, "The Emancipated Woman,"
wood engraving, *Puck*, February 1895. Library of Congress.

smoking cigarettes, to more degrading and misogynist images in which women are characterized as threatening and bestial.[45] Samuel Ehrhardt's 1895 "The Emancipated Woman" (fig. 19) deals with some of these gender reversals in a highly amusing way. A huge, stout woman looms in the foreground dressed in bloomers, a tie, and suspenders. She has the face of a man, with coarse and exaggerated features. With her powerful build, she physically dominates her timid and feeble husband, who appears seated by the hearth feeding their infant with a bottle. Images such as this abound from the 1890s, showing women wearing the pants in the family both literally and figuratively. In these works, manly women intimidate effeminate men.[46]

THE SPORTING AND ATHLETIC WOMAN

During the last quarter of the nineteenth century, the manly woman was closely allied with yet another new type, the sporting or athletic female. Engaging in recreational activities and playing sports, women rejected the belief that they were by nature weak, passive, and dependent. Athletic women became a popular subject with painters, illustrators, and photographers. Again, Homer was the first to focus repeatedly on this new type when, in the late 1860s, he painted sporting women in a series of croquet scenes. In these works, modern women are shown successfully competing with men in a game that required skill and ingenuity rather than great physical strength.[47] Later in the century, women engaged in sports that were more physically demanding. By the mid-1870s, they played tennis, a game that required strength, stamina, and agility. Illustrators and photographers delighted in depicting energetic women participating in this physically challenging sport.[48] In their pictures, they show women on grass courts, running, lunging, and hitting balls.

However, when female tennis players appear in the paintings of William Verplank Birney, Otto H. Bacher, and Robert Vonnoh, they are shown holding rackets, but not actually playing the game. Vonnoh's *The Ring* of 1892 (fig. 20) is a huge canvas in the center of which the artist juxtaposes two types of women: the newly engaged virgin dressed in white and the athlete holding a tennis racket. The virgin has the facial features of Vonnoh's wife. Slim and attractive, she sits in a passive, upright, and modest pose with her hands in her lap. In contrast, the tennis player is heavy-set with a square jaw and a large mouth. Dressed in a tie and shirt that further emphasize her masculine qualities, she bends forward with her arms open in an aggressive and active stance. Without question, this energetic figure is related to the manly woman, who was a staple of the popular press. Vonnoh's characterization is remarkable because it represents one of the few examples in painting of this type. Her inclusion in the finished painting came late in the artistic process, because in two of the preliminary sketches this figure does not appear.[49]

But bicycling, more than any other activity, became associated with the New

Fig. 20. Robert Vonnoh, *The Ring,* 1892, oil on canvas, 60 1/4 x 72 1/2 in. (153 x 184 cm).
Courtesy Berry-Hill Galleries, New York, N.Y.

Woman. In the 1890s, the cycling craze peaked with the development of the "safety bicycle," which had pneumatic instead of iron tires. Relatively comfortable, the "safety bicycle" gave women the ability to travel independently as well as forcing them to don some form of pants in order to ride without injury.[50] Reactions to female riders in the popular press varied: while satirists delighted in depicting them in titillating poses, they were also used as symbols of liberation and modernity. As the 1896 edition of *Munsey's* magazine stated, "To women, it was a steed upon which they rode into a new world."[51] Well-known illustrators

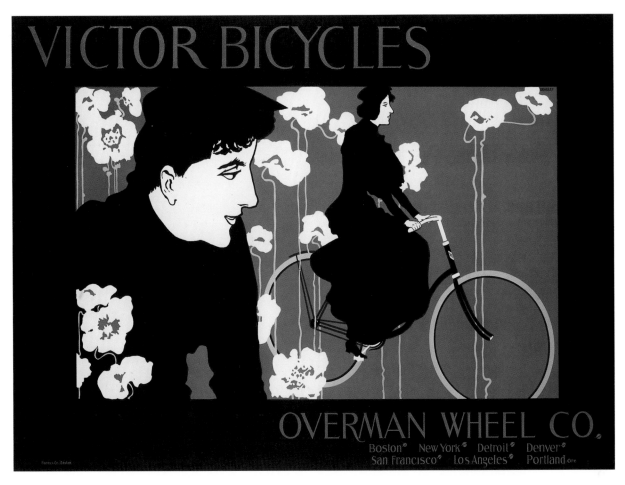

FIG. 21. Will Bradley, "Victor Bicycles / Overman Wheel Co.," 1895, lithograph.
Published by the Overman Wheel Company, printed by Forbes Co., Boston.
The Metropolitan Museum of Art, Gift of Leonard A. Lauder, 1986 (1986.1207).

such as Gibson and Will Bradley were drawn to the New Woman cyclist. Gibson
shows a beautiful, self-confident, and dignified lady in an 1896 illustration that
appeared in *Scribner's* (fig. 1) while Bradley's commercial lithograph, *Victor Bi-
cycles* (fig. 21), for the Overman Wheel Company, suggests a romantic connec-
tion between the male figure in the foreground and the distant lady perched on
her vehicle. The implication is that he is dreaming about this beautiful, but
rather unapproachable figure.

Although the female cyclist was a staple of prints, posters, and photographs
in the 1890s, she rarely appears in the paintings of the period. However, in 1892
Henry dealt with this topical subject in *The New Woman* (fig. 22) where she is

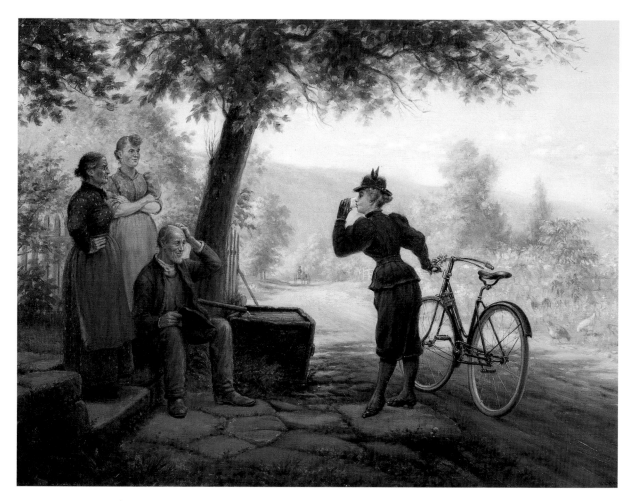

FIG. 22. Edward Lamson Henry, *The New Woman*, 1892, oil on canvas,
16 x 22 in. (40.64 x 55.88 cm). Private collection, Illinois.

portrayed humorously as a strange and unnatural creature who has momentar-
ily arrested her journey for a drink of water.[52] Henry's satirical interpretation re-
lates to Vonnoh's in *The Ring* (fig. 20) because both focus on contrasting female
types. Dressed in bloomers and grasping her bicycle, Henry's athlete dominates
the composition. Not only is her dark outline dramatically silhouetted against a
luminous landscape, but she is also prominently placed in such a way that she oc-
cupies almost three-quarters of the canvas. Grouped compactly on the left are
three rural types: a farmer who scratches his head bewildered by the odd female
and two country women in aprons. Henry actually bisects the composition,
using a tree to physically distance the traditional women from the bicyclist in

order to underscore the fact that the New Woman and these rural folk are worlds apart. On a more profound level, however, the artist is contrasting America's agrarian past, symbolized by the country figures, with its future, embodied by the modern cyclist who travels freely and independently on the open road.

THE NEW WOMAN

By the 1890s, the New Woman emerged as a highly visible and recognizable image of modernity and liberation in art, literature, and the popular press. The ubiquitous Gibson Girl and variations of this type proliferated on the pages of *Life, Puck,* and *Scribner's* magazines while bicycle manufacturers used the New Woman on their promotional posters as alluring symbols of health, beauty, and independence. In the fine arts, masterful painters like Eakins, Chase, and Sargent produced powerful portraits of women whose intelligence, vitality, and forceful personalities were highlighted. These artists created monumental, life-size portraits of exceptional women whose biographies support the artists' interpretation of them as fascinating and physiologically complex. Simultaneously, female artists like Hale, Coffin, and Nourse created compelling self-portraits in which they fearlessly presented themselves as individuals willing to flout social codes and challenge accepted ideas regarding women's place in society. Indeed, the New Woman portraits of the 1880s and 1890s are unforgettable interpretations of energetic, self-confident, and accomplished women.

Eakins's *The Concert Singer* (fig. 23) is a remarkable painting for the period because it depicts a woman on stage in the act of performing, a subject that fine artists had rarely attempted. Although Eakins previously had focused on a woman singing in his 1881 *The Pathetic Song* (Corcoran Gallery of Art, Washington, D.C.), he situated her in the privacy of a domestic setting surrounded by other figures playing instruments. In *The Concert Singer,* however, Weda Cook appears alone on an empty stage. A mezzo-soprano who had made her debut at the Philadelphia Academy of Music at the age of sixteen, Cook was a committed professional. Even after her marriage, she continued to perform in public despite the fact that

married women were not expected or encouraged to have careers. With her mouth open in song and her powerful, swelling neck highlighted, Cook dominates the composition. Her dazzling pink dress contrasts dramatically with the stark, dark setting with its undefined space and draws further attention to the sitter. Eakins includes only a few essential details, primarily to underscore the fact that Cook is singing to an enthusiastic audience. By including the bouquet of roses at her feet thrown by an admirer, Eakins references her successful career and the recognition she received in her Philadelphia performances. In this amazing detail, flowers, the traditional attribute of feminine beauty and fragility, have been transformed into a symbol of public acclaim.[53] Although the hand and baton indicates the male presence of the conductor, she does not look in his direction or in any way acknowledge his presence, but rather she appears totally absorbed in the physical, mental, and emotional effort of her all-consuming creative act.

Over a decade later, Chase also painted a full-length portrait of a well-known performer on stage (fig. 24). Hilda Spong is a symphony in gray whose only prop, a curtain, places her in the theater.[54] Whether she is about to begin her performance or has just finished cannot be determined, but she is definitely on public display. As she draws back the drapery, a glimpse of the stage is visible, while her open stance exposes her curvaceous body. Although Spong is shown frontally in full view, her expression is illusive. She seems absorbed in a private reverie, perhaps involving her theatrical role, or basking in the applause of the audience. By depicting Spong in the public arena, Chase, as Eakins had done earlier, underscored the growing presence of women professionals in the performing arts, one of the few fields where they could command high salaries that were comparable to those of their male colleagues.[55]

Chase's admiration for talented, professional women is also reflected in his decision to paint two of his most accomplished students: Dora Wheeler and Lydia Field Emmet. In these magnificent portraits, Chase broke with tradition in order to create pictures of audacious and self-confident women. Dated 1883, the *Portrait of Miss Dora Wheeler* (fig. 25) is one of the earliest full-length images of a New Woman. The daughter of Candace Wheeler, a famous designer and founding member of Associated Artists, Dora Wheeler was an aspiring painter when Chase

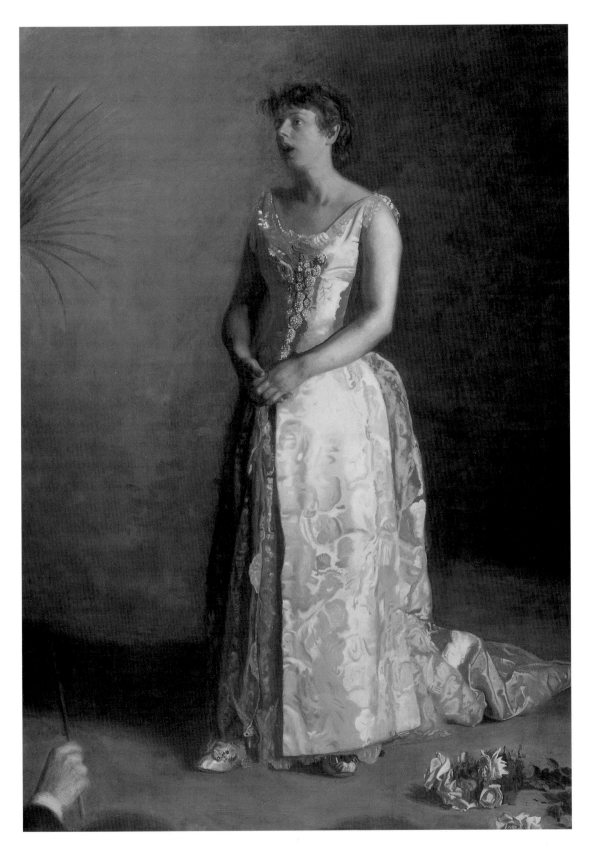

Fig. 23. Thomas Eakins, *The Concert Singer*, 1890–1892, oil on canvas,
75⅛ x 54⅛ in. (190.8 x 137.8 cm). Philadelphia Museum of Art,
Gift of Mrs. Thomas Eakins and Miss Mary Adeline Williams, 1929.

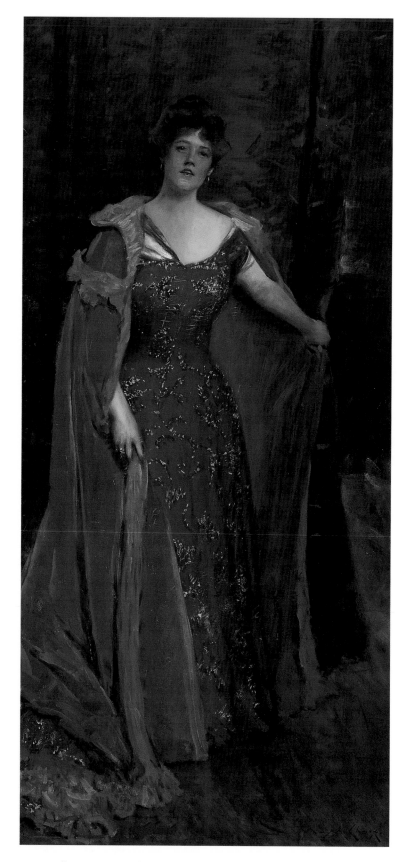

Fig. 24. William Merritt Chase, *Hilda Spong*, 1904, oil on canvas, 84⅛ x 39½ in.
(213.68 x 100.33 cm). Virginia Museum of Fine Arts, Richmond.
Gift of Ehrich-Newhouse Galleries, in memory of Walter L. Ehrlich, 36.7.1.

asked her to model. Chase situates her in her own studio in front of a spectacular gold silk tapestry that was probably one of the recent creations of the newly reconstituted Associated Artists firm, now headed by Dora and Candace.[56] Framed by dark, curly bangs, a badge of emancipation, Wheeler's face has a reflective expression accentuated by her pointing finger, which emphasizes her head. In this work, the thinking woman is clearly identified. Today this picture is recognized as one of Chase's masterpieces, as the art historian Karal Ann Marling suggests, "Miss Wheeler may be the most forceful, dispassionate study of personality Chase would ever produce." Contemporary commentators, however, were disparaging. In his 1883 review of the painting for the *Magazine of Art,* the critic William C. Brownell wrote, "The first necessity of a portrait from the point of view of art is . . . that it should be agreeable; and agreeable this portrait certainly was not."[57] While Brownell cites aesthetic failures, he was probably more offended by what he considered the disagreeable qualities of the sitter: her obvious intelligence and independence. Even in the 1880s, portrayals of new women were considered transgressive; Miss Wheeler was neither submissive nor demure in her demeanor, causing viewers to censure Chase's challenging interpretation.

In his circa 1893 *Lydia Field Emmet* (fig. 26), Chase depicted one of his students in an even more daring pose. Master and pupil enjoyed a particularly close working relationship at the time, which may account for Chase's startling interpretation. Emmet was studying with him at the Art Students League in New York City and he had asked her to teach at his summer school in Shinnecock Hills, Long Island. In this portrait, Emmet exudes self-confidence. Chase positions her head at the very top of the canvas so that she towers over the viewer in a commanding, almost regal pose with her arm akimbo, the gesture that by the 1890s signaled the emancipated woman. Her serene and somewhat detached expression contrasts with the agitated, bravado brushstrokes of the long pink ribbon that falls dramatically to the floor, further accentuating the height of the figure. If Emmet's attitude appears superior, her confidence stems from her accomplishments and talents.

Indeed, the 1890s were a heyday for portraits of fiercely independent women. In 1897 and 1898, Sargent created two extraordinary, iconic images of the New Woman: *Mrs. Charles Thursby* (fig. 27) and *Mr. and Mrs. Isaac Newton*

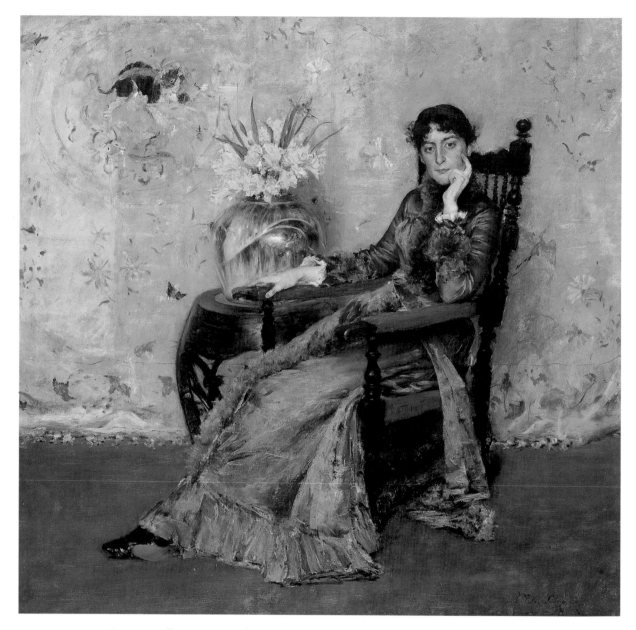

FIG. 25. William Merritt Chase, *Portrait of Miss Dora Wheeler*, 1883, oil on canvas,
62½ x 65½ in. (159 x 165.5 cm). The Cleveland Museum of Art.
Gift of Mrs. Boudinot Keith in memory of Mr. and Mrs. J. H. Wade, 1921 21.1239.

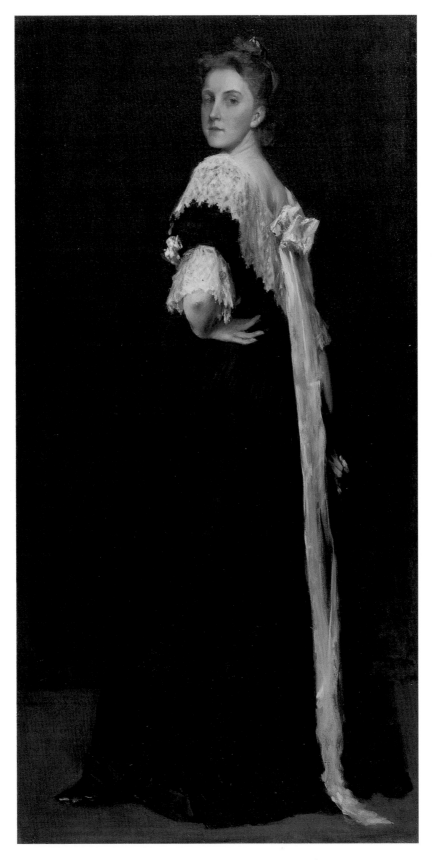

Fig. 26. William Merritt Chase, *Lydia Field Emmet*, ca. 1893, oil on canvas, 71⅞ x 36¼ in. (182.6 x 92 cm). The Brooklyn Museum, Gift of the Artist, 15.316.

Phelps Stokes (fig. 28). In each, Sargent clearly identifies the sitters as new women through their clothing, poses, and demeanor. Attired in mannish shirtwaists that were associated with the dress reform of the period, Alice Thursby and Edith Stokes are characterized as dynamic and assertive. Sargent ignores convention by underscoring their vitality during a period when most portraitists emphasized the passivity of their female sitters. Seated off-center in the corner of the artist's studio chair, Thursby leans aggressively into the viewer's space with her head tilted at an angle. Her pose is unusually active for the period: hands on hips, the quintessential New Woman gesture, and legs crossed in a manner that would have been considered undignified at the time. Simultaneously, Sargent activates the entire composition with a series of strong diagonals that include her arms and the fabric of her dress undulating in rhythmic waves. The artist's signature brushstrokes further energize the surface of the canvas, creating a composition that reinforces Sargent's interpretation of Thursby as an edgy personality.

Edith Stokes is also shown as a vital personality whose beauty derives more from her clear complexion and animated demeanor than from the expensive clothing and accessories that frequently appear in Sargent's society portraits. According to Stokes's memoir, Sargent changed his initial plan to paint her in a formal evening gown, deciding later that the casual dress of shirtwaist and skirt better suited her vivacious and energetic nature. She voiced concerns, but conceded to Sargent's request. "We thought it wise to submit to his whim, although we had, even then, some apprehension lest our friends at home . . . might not altogether approve."[58] Stokes realized that Sargent's interpretation was daring, but her secure social standing and wealth protected her from serious censure. Equally audacious was Sargent's portrait of her husband. Although Isaac Stokes was a late addition, which helps to account for his sketchy figure, he is completely dominated by the solid, physical presence of his brightly-lit wife. His marginalized position in the shadowy background adds to his uncanny characterization; some critics have interpreted the provocative placement of his wife's hat as an act of emasculation.[59]

In 1899, at the close of the nineteenth century, Sargent created his most austere and serious portrait of a New Woman. M. Carey Thomas confronts the viewer head on (fig. 29). The solid modeling of her face creates an intensely

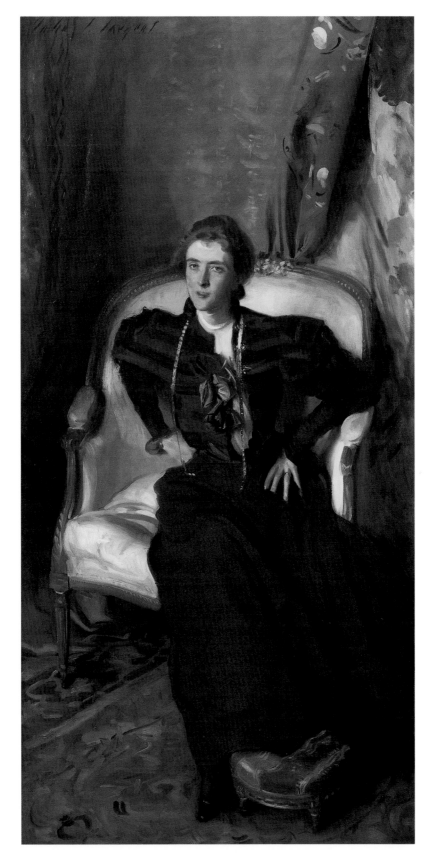

Fig. 27. John Singer Sargent, *Mrs. Charles Thursby*, ca. 1897–1898, oil on canvas, 78¼ x 39½ in. (198.75 x 100.33 cm).
The Newark Museum, Purchase by exchange 1985—Gift of Mr. and Mrs. Duncan Pitney,
Emilie Coles (from the J. Ackerman Coles Collection), Mrs. Lewis B. Ballantyne,
Mrs. Owen Winston and the Bequest of Louis Bamberger 85.45.

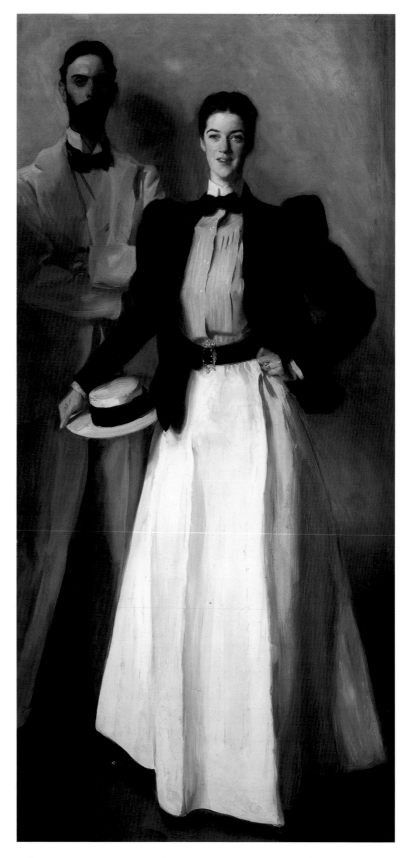

FIG. 28. John Singer Sargent, *Mr. and Mrs. Isaac Newton Phelps Stokes*, 1897, oil on canvas,
84¼ x 39¼ in. (214 x 101 cm). The Metropolitan Museum of Art, Bequest of Edith Minturn
Phelps Stokes (Mrs. I. N.), 1938 (38.104).

realistic visage, while Thomas's illuminated forehead references her brilliant mind. Thomas, who had fought for women's right to higher education, is shown in her black academic robes, edged with dark blue Ph.D. stripes.[60] In this work, the lack of extraneous details, accessories, and a defined setting is noteworthy. Nothing detracts from Thomas's penetrating, contemplative gaze. Perhaps Sargent's most psychological female portrait, *Miss Carey Thomas* creates the impression of a sage, forceful, and intelligent sitter, the type found almost exclusively in Sargent's male rather than his female portraits. This portrait was commissioned by the committee of alumnae and students of Bryn Mawr College where Thomas was its second president from 1894 to 1922.

Ultimately, the question arises: Why were so few new women portraits produced during the nineteenth century? Chase and Sargent, who each painted hundreds of likenesses, created only a handful of images of emancipated women. Obviously, public censure was a significant factor, as demonstrated by Brownell's reaction to Chase's interpretation of Dora Wheeler. Another possible explanation is that artists found it easier to rely on traditional formulas. While painters strive to be innovative and creative, tried-and-true poses and accessories result in both successful compositions and satisfied customers. However, when masters like Chase and Sargent were confronted with exceptional women, they sometimes responded by creating compelling portraits. Obviously, the chemistry had to be right for the collaboration between artist and sitter to result in a psychologically penetrating characterization.

CONCLUSION

By the end of the nineteenth century, portrayals of new women were enormously diverse, reflecting the multiplicity of roles available to women as well as the conflicted attitudes that they engendered. During a period of tremendous social change and dislocation, artists infused their interpretations of emancipated women with their fears for the future as well as their optimism for the new century. In the popular press, illustrators vented their hostility toward

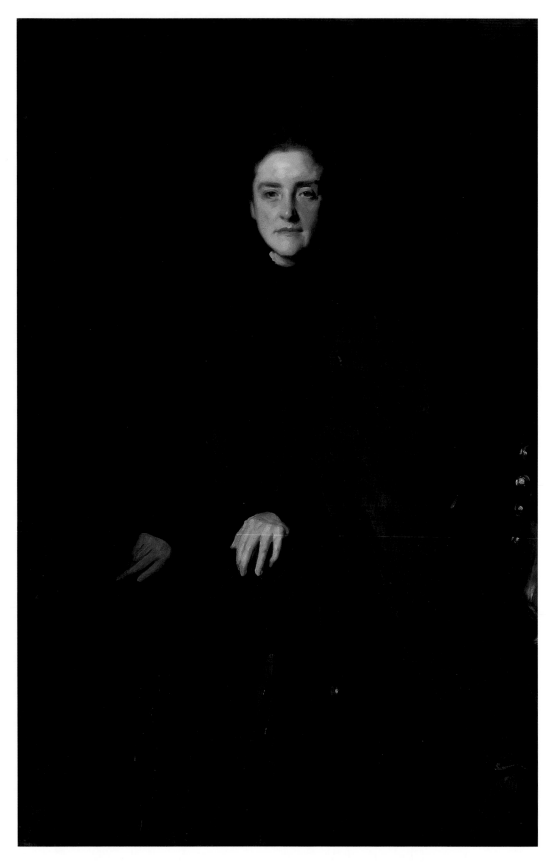

FIG. 29. John Singer Sargent, *Portrait of Miss Carey Thomas, President of
Bryn Mawr College (1894–1922)*, 1899, oil on canvas, 58 x 38 in. (147.32 x 96.52 cm).
Bryn Mawr College, Bryn Mawr, Pa.

female independence in their brutally misogynist depictions of the perverse and manly woman. Yet, fine artists frequently focused on female intelligence, vitality, and strength. Beginning in the 1860s and 1870s, Homer championed new women in his paintings and engravings, forging a path that was initially followed by Cassatt in France and later by Chase, Johnson, and Henry. In these early interpretations, new women frequently appear as types that embody a single, dominant aspect of the emerging emancipated woman. The intimate scale of these works indicates that they were produced for domestic settings where they were viewed in private.

During the last two decades of the nineteenth century, the New Woman is individualized to a greater extent. She now takes center stage in the riveting portraits by Eakins, Chase, and Sargent and the bold self-portraits by Nourse, Coffin, and Hale. These paintings rank among the most memorable female portraits of any age and capture the viewer's attention in their imposing scale and the sitters' striking stances and penetrating gazes. While images of new women represented only one of the many different female types that permeate the visual culture during the second half of the nineteenth century, they were, without question, the most highly contested and provocative.

This first generation of new women should be seen as precursors of modern women of the twentieth century because they challenged traditional attitudes about women's temperament and capabilities. They provided a strong foundation for future generations of emancipated women, who in 1920 with the passing of the Nineteenth Amendment gained the right to vote.[61] Indicative of how dramatically women's lives have changed over the last century is the fact that the images of new women discussed in this essay were considered radical and controversial in the late nineteenth century, while today they seem familiar and totally acceptable.

WINSLOW HOMER'S AMBIGUOUSLY NEW WOMEN

ॐ

SARAH BURNS

The years 1868 to 1870 saw the emergence of a newly energized and highly controversial women's movement in America. In 1868, the first issue of the feminist magazine *Revolution* appeared, and Jane Croly (a feminist who would soon become editor of the influential fashion magazine *Harper's Bazar*) founded the Sorosis Club for professional women in New York. In 1869, John Stuart Mill published *The Subjection of Women,* a vigorous and hotly debated critique of oppressive patriarchal institutions. That same year, women got the vote in the Wyoming Territory. Also in 1869, the scandalous Victoria Woodhull burst upon the New York scene. Bankrolled by Cornelius Vanderbilt, she launched a Wall Street brokerage firm and began to publish the radical newspaper *Woodhull & Claflin's Weekly,* which embraced both feminism and free love. During that same period, the organized women's rights movement itself was in turmoil, ultimately splitting between the radical, New York–based National Woman Suffrage Association and the more genteel, Boston-based American Woman Suffrage Association.[1]

It was just then, in 1870, that Winslow Homer chose to exhibit at the National Academy of Design a triad of paintings celebrating the modern American woman out of doors: *Eagle Head, Manchester, Massachusetts* (fig. 30), *The Bridle Path, White Mountains* (fig. 31), and *Manners and Customs of the Seaside* (present location unknown). All three depicted contemporary young women at leisure, sea-bathing or trail-riding. It was not Homer's first foray into such subjects, but it was unquestionably his most ambitious. Large and imposing in scale, *Eagle Head* and *Bridle Path*—equal in size to the artist's much-heralded Civil War painting, *Prisoners from the Front* (1867; Metropolitan Museum of Art, New York)— announced Homer's intention to observe and paint modern life as modern history, more specifically, modern *female* history.

A bachelor in his early thirties, Homer might well be expected to pursue the young, marriageable woman in art as in real life. But the congruence of this subject with the emergence of the contentious, vehemently public feminist vanguard suggests that more than personal interest was at stake. At a time when the women's movement was aggressively on view, Homer assumed the role of visual anthropologist, observing, recording, and interpreting the mores of American girlhood and young womanhood. Who are these women Homer depicted, riding, swimming, skating, shopping, teaching, reading, hiking? What did Homer think of them, and why did he choose to represent those particular pursuits? Did he wholeheartedly endorse young womanhood, American-style, or did he view modern femininity (and feminism) with trepidation? What visual cues and clues implanted in his pictures enable us to tease out answers to these questions?[2]

Homer's *Bridle Path* ushers us into the social and aesthetic territory of modern American femininity.[3] For Homer's friend, the painter and critic Eugene Benson, the artist's vision of the young mountain tourist seemed to symbolize America itself:

> It is so real, so natural, so effective, so full of light and air; . . . the action
> of the horse is so good, the girl sits so well; she is so truly American, so del-
> icate and sunny, that, of course, you surrender yourself to her breezy,
> health-giving ride; you look at her with gusto. . . . Here is no faded, trite,

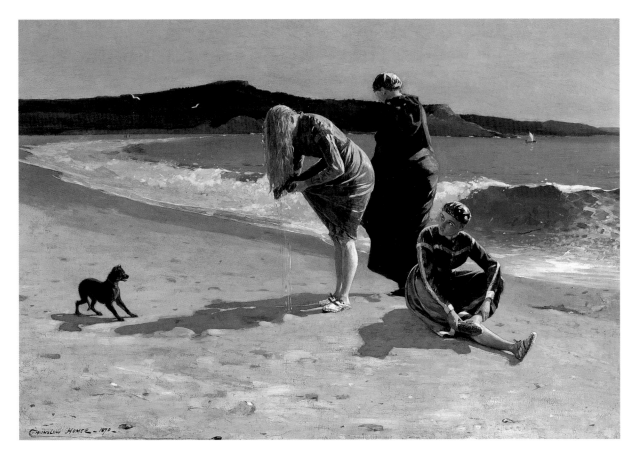

Fig. 30. Winslow Homer, *Eagle Head, Manchester, Massachusetts (High Tide)*, 1870,
oil on canvas, 26 x 38 in. (66 x 96.5 cm). The Metropolitan Museum of Art,
Gift of Mrs. William F. Milton, 1923 (23.77.2).

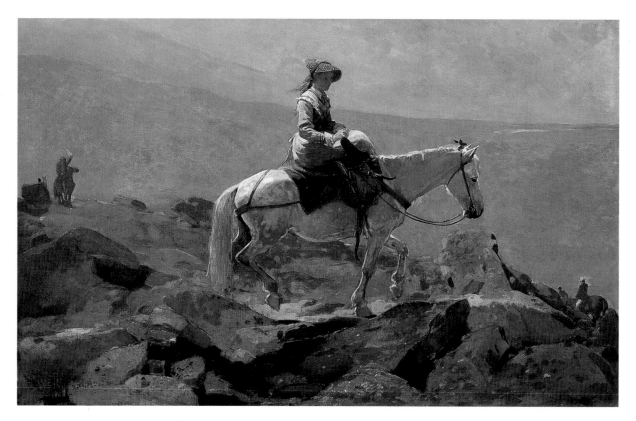

FIG. 31. Winslow Homer, *The Bridle Path, White Mountains*, 1868, oil on canvas,
24⅛ x 38 in. (61.30 x 96.50 cm). 1955.2,
Sterling and Francine Clark Art Institute, Williamstown, Mass.

flavorless figure, as if from English illustrated magazines; but an American girl out-of-doors, by an American artist with American characteristics—a picture by a man who goes directly to his object, sees its large and obvious relations, and works to express them, untroubled by the past and not thinking too curiously of the present.[4]

In Homer's painting, the young rider on her placid white horse dominates the composition. She sits squarely on the vertical axis, her head the high point of the expansive, mountainous scene. Reins loose, the horse picks its way among chunky granite slabs. Far back on the left, a man waving a white handkerchief has brought his horse to a standstill. Behind him, another rider is just coming into view. Below on the right, two more riders, a man and a woman in red, are just about to disappear around a bend. Homer's rider travels alone. Perched sidesaddle, she wears a long-sleeved white dress with a sash, a ruched triangular yoke, and a striped scarf knotted at the neckline. Bands of narrow black braid trim the yoke and the cuffs of her sleeves. Protecting her hands are white gauntlets; shading her head is a yellow straw "gypsy" hat tied on with a long blue ribbon that streams down her back while a lock of her fine yellow hair floats in the breeze.[5]

While the girl in *The Bridle Path* is solo, in *Mount Washington* (fig. 32) she travels with another woman on horseback, and they in turn are attended by two dapper young men. The *Harper's Weekly* wood engraving, "The Summit of Mount Washington" (fig. 33), shows the same two women in the foreground; ahead of them, several couples wind their way on foot to the mountaintop.[6] Homer often worked in serial format and transported figures from one composition to another, with slight variations. In *Mount Washington,* accordingly, the rider of *Bridle Path* wears a dark fichu with red stripes and holds a long riding crop or whip; in the wood engraving she has a plain bodice, drop earrings, a stiff fringed neck ribbon, and what appears to be a ruffled overskirt.

Do these details signify more than the artist's pleasure in toying with the fine points of fashion? We can probe this question by turning to the other rider in the two works from 1869. We cannot see her face, averted in the *profil perdu* that Homer used repeatedly in many paintings and illustrations of the late

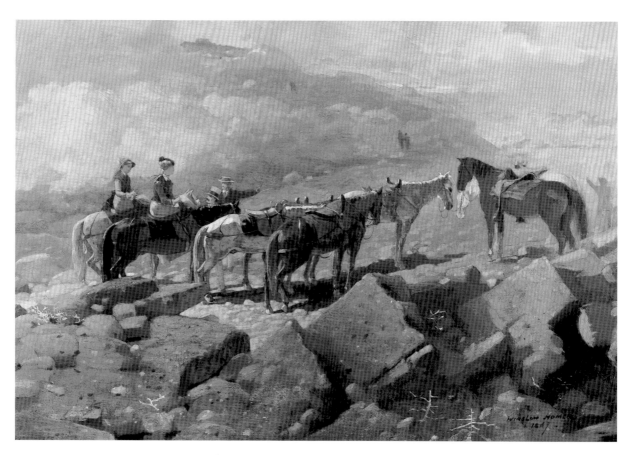

FIG. 32. Winslow Homer, *Mount Washington*, 1869, oil on canvas,
16¼ x 24⁵⁄₁₆ in. (41.27 x 61.75 cm). The Art Institute of Chicago,
Gift of Mrs. Richard E. Danielson and Mrs. Chauncey McCormick, 1951.313.

1860s. In both, however, she cuts a much more urbane and natty figure, with her bulging chignon, jaunty hat, flowing skirt, and dark jacket with white collar and tiny peplum. Her body language is different, too. In *Mount Washington* the rider in white holds a long riding crop decorously upright. In "The Summit of Mount Washington" her natty companion holds the crop instead, aggressively brandishing it over her horse's neck.

The natty rider's dress and deportment are consistent with the figure of the equestrienne as represented in contemporary fashion plates. Fashionable riding habits combined the tailored jacket (or basque) with a plain skirt and a stiff, shiny hat wound with a voluminous veil designed to flutter gracefully with the rider's movement (fig. 34). According to *Harper's Bazar* in 1869, the most popu-

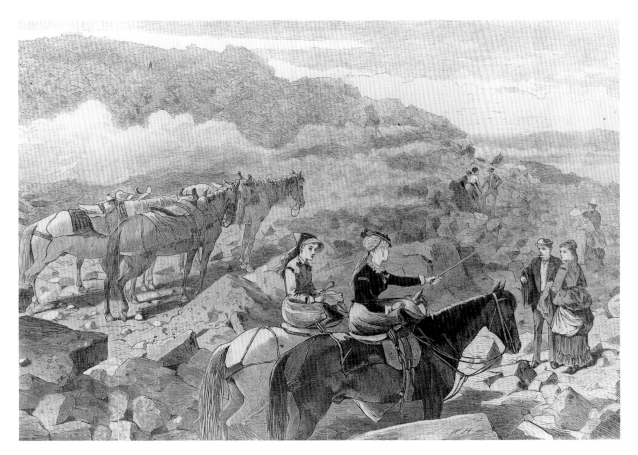

FIG. 33. Winslow Homer, "The Summit of Mount Washington," wood engraving, *Harper's Weekly*, July 10, 1869. Bowdoin College Museum of Art, Brunswick, Maine, Museum and College Purchase, Hamlin, Quinby, and Special Funds.

lar colors for country riding were dark: black and an "almost invisible shade of blue," with "heavy gray linen" as second-best for wearing on dusty roads. For rural rides, the high silk hat might be replaced with a flat-crowned hat of braided straw, with velvet facing on the brim and trimmed with ostrich feathers or flowers.[7] We see such hats in Homer's illustration "May-Day in the Country," (fig. 35) as well as other accoutrements—the tailored jackets and flowing skirts—that reflect fashionable trends.

At once dashing and severe, such costumes enhanced the air of Amazonian androgyny or mannishness often associated with the equestrienne. In "The Summit of Mount Washington," the tailored habit and aggressive body language of the fashionable rider have a distinctly Amazonian edge. It is probably

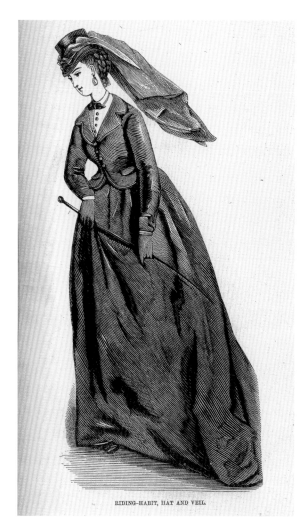

RIDING-HABIT, HAT AND VEIL.

Fig. 34. Full-page fashion plate of "Riding-Habit, Hat and Veil," wood engraving, *Peterson's*, April 1870. Indiana University Library, Bloomington.

no accident that she sits on a male horse, whether stallion or gelding impossible to determine, but whatever the case firmly under his whip-wielding mistress's control. The running martingale that prevents her mount from tossing back his head acts as an additional curb to his freedom.

Almost point for point, the rider in white stands in dramatic contrast to the whip-waving young Amazon atop her more tightly restrained mount. In *Mount Washington* Homer plays off the Amazon in crisp grays against the other, both softer and fussier in her colorful fichu and girlish blue hat ribbons. In "The Summit of Mount Washington," she sits with less assurance, clutching the reins like

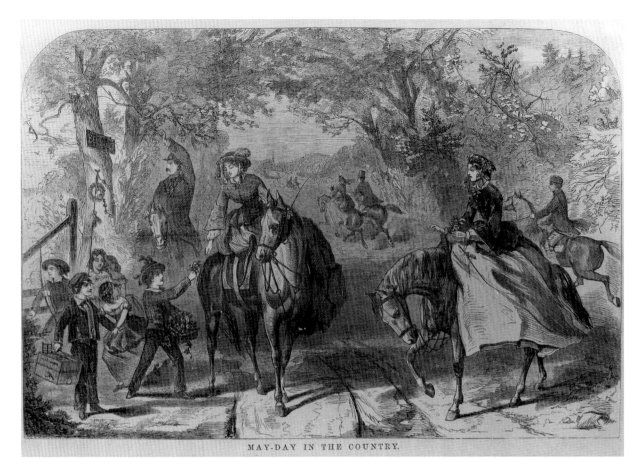

MAY-DAY IN THE COUNTRY.

Fig. 35. Winslow Homer, "May-Day in the Country," wood engraving, *Harper's Weekly*,
April 30, 1859. Bowdoin College Museum of Art, Brunswick, Maine, Museum
and College Purchase, Hamlin, Quinby, and Special Funds.

a novice and perching uneasily in her inappropriate ruffles and gypsy hat. And
in *The Bridle Path* itself, even without an Amazon nearby, she is obviously no
fashionable equestrienne but rather a tourist, a beginner mounted on an inde-
terminately gendered trail horse, sure-footed and sedate.

She is also, explicitly, *not* a Girl of the Period. The Girl of the Period—sym-
bolizing the worst tendencies of modern American girlhood—was the focus of
heated controversy in the late 1860s. A brazen female in her teens or early twen-
ties, she strode fearlessly into the public realm, appropriating masculine man-
nerisms and habits, devoting herself to fashion and leisure, and forswearing
domesticity. The magazines abounded in cartoons and admonitory articles con-
trasting old virtues with new vices and showing Girls of the Period subversively

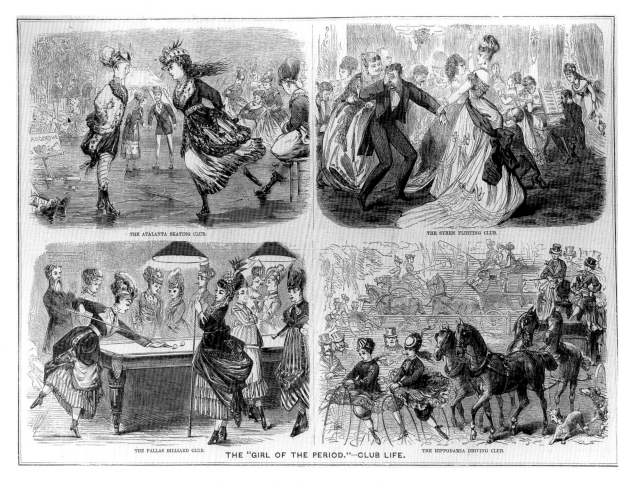

FIG. 36. "The 'Girl of the Period'—Club Life," wood engraving, *Harper's Bazar*, January 30, 1869. Indiana University Library, Bloomington.

flaunting themselves. Smoking and drinking, they played billiards or skated in short skirts and outlandish headgear. They overpowered and emasculated men; they wore bloomers, rode bicycles, and—in top hats, wielding whips—drove four-in-hand coaches (fig. 36).[8] Their fashions were so extreme that they distorted the female body out of all recognition, producing what commentators derided as the "Grecian Bend" (fig. 37), a combination of tight corset, prominent bustle, and very high heels that thrust the torso forward, forcing the wearer to tilt and totter as she walked.

Critics urged dress reform as the first and most basic antidote to such pernicious modern tendencies. Almost invariably, they attacked the grotesque artificiality of contemporary fashion, decrying the bodily distortion, the enormous

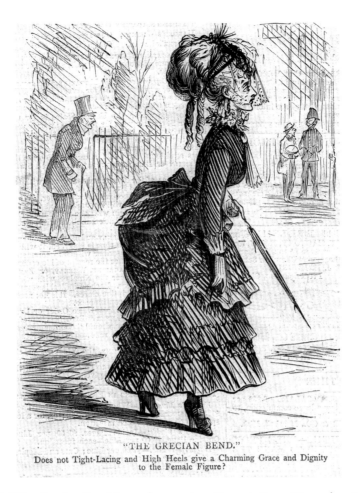

"THE GRECIAN BEND."
Does not Tight-Lacing and High Heels give a Charming Grace and Dignity
to the Female Figure?

FIG. 37. "The Grecian Bend," wood engraving, *Harper's Bazar,* November 6, 1869.
Indiana University Library, Bloomington.

wads of false hair, the obsession with ornament and trimmings. Dio Lewis, the outspoken Boston reformer, declared the "trimming mania" frightful and asked rhetorically, "What do you think of one hundred and twenty yards . . . of ribbon in the trimming of one dress?" Overloaded with trinkets, American girls (in the eyes of Lewis and many others, including Homer's friend Benson) were idle and languid, passing much of their time in lengthy visits and filling the rest with "the dressmaker, piano practice, the theatre, working sickly-looking pink dogs in worsted, lying late in the morning, dressing three times a day, and reading a few novels."[9] Lewis's vision of the fashionable Girl of the Period—lazy and soft—contradicts the caricatures in which "Girls" so vigorously pursue outdoor activities, but this disparity only serves to highlight the unease and confusion these

bold nonconformists inspired. Interestingly, one hostile critic identified the seated figure in Homer's *Eagle Head* (fig. 30) as a "fair representation of 'the girl of the period,'" and another took the painting to be a "satire on the fashionable eccentricities of Grecian bends and other modern dress addenda."[10] Harriet Beecher Stowe and Louisa May Alcott both wrote tales contrasting the type of the selfish, sickly city belle with her unspoiled country cousin. Stowe's *Little Pussy Willow* tells the story of a simple country girl who grows up in the "healthy air of the mountains" and whose greatest joy is in helping her mother make bread, or caring for her cow, Clover. Emily Proudie is the peevish little fashion plate sent to Pussy Willow's farm to recover her health, broken by "the corsets and the hot rooms with plenty of gas escaping into them from leaky tubes, and . . . operas and Germans [late-night dance parties] for every night of the week," as her physician puts it. Such a wilted lily at first that she cannot even climb into the hayloft without Pussy Willow's help, Emily soon has pink cheeks, a natural waistline, and a sunnier disposition.[11]

Alcott conceived of the heroine in *An Old-Fashioned Girl* as a "possible improvement upon the Girl of the Period, who seems sorrowfully ignorant or ashamed of the good old fashions which make woman truly beautiful and honored, and, through her, render home what it should be." In Alcott's story, the ingenuous Polly comes to stay with the wealthy Shaws in Boston. Young Fanny Shaw, like Emily Proudie, is precociously modish, with a "pile of hair on top of her head, . . . a fringe of fuzz round her forehead, and a wavy lock streaming down her back," a "scarlet-and-black suit, with [a] big sash, little *pannier*, bright buttons, points, rosettes—and heaven knows what." Polly, by contrast, has short hair, a "plain hat without a bit of feather," a simple blue merino frock, and stout boots. When Fanny takes her to the theater one evening, Polly finds the performance horribly embarrassing: "four-and-twenty girls, dressed as jockeys, came prancing on to the stage, cracking their whips, stamping the heels of their top-boots, and winking at the audience." Used to running, riding, rowing, and playing vigorously in the open air, Polly chafes at Fanny's fashionable routine: there is nothing to do but "lounge and gossip, read novels, parade the streets, and dress." Gradually, Polly makes her influence felt to create better atmosphere in

the dysfunctional Shaw family, and in due time, Fanny learns that love rather than money is the true source of happiness.[12]

These stories are schematic and transparently didactic. They idealize the country girl and demonize her urban counterpart. Little Pussy Willow and Emily Proudie, Polly and Fanny Shaw were by design extreme opposites. In both cases, the wholesome example of the country girl in time reversed the vicissitudes of fashion and restored the Girl of the Period to her senses. The message was all in the contrast and not in the medium.

In real life at the time, nothing was so simple, or so transparent. Middle-class American girls, less domestic than their mothers, did enjoy more control over their time, and they spent it more freely in pleasurable or educational pursuits. They continued to perform household duties, such as dusting parlor knick-knacks, but increasingly their parents "found a range of [other] things for a daughter to do, including the ornamental skills of sewing, playing piano, writing and reading associated with self-culture." Significantly, parents more and more often sent daughters to coeducational secondary schools, where they both socialized with and competed with boys. Young students promenaded city streets in groups or even alone. Many girls routinely walked considerable distances each day for their health. In public urban space, girls skated, flirted, went to pastry shops, watched parades, and ogled store-window displays. The social historian Jane H. Hunter cites the diary of Charlotte Perkins (later to become the passionate feminist Charlotte Perkins Gilman) to suggest how much freedom young middle-class Victorian women enjoyed in public. Studying at the Rhode Island School of Design, Perkins skated and walked with friends of both sexes, took the train to Boston unescorted, and went to the theater, unchaperoned, with young men.[13] Hunter's study makes clear that Gilman and her peers were complex and serious young women who studied, dreamed, and hoped for more in life than marriage and motherhood.

Different *types* of modern girls were very much on Homer's mind, too, in the late 1860s when he began to study their world and their day-to-day rituals. "Opening Day in New York" (fig. 38) is both an acutely observed visual chronicle of young New Yorkers shopping for spring fashions *and* a critique worthy of

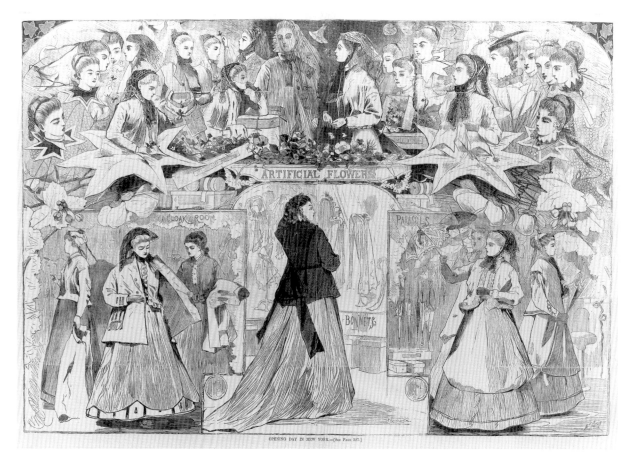

Fig. 38. Winslow Homer, "Opening Day in New York," wood engraving, *Harper's Bazar,*
March 21, 1868. Bowdoin College Museum of Art, Brunswick, Maine, Museum Purchase,
Lloyd O. and Marjorie Strong Coulter Fund.

Alcott or Stowe. In the bottom register, girls try on new cloaks, contemplate
bonnets, and flourish the latest style in parasols. On the top, above a table full of
"Artificial Flowers" we see the girls as exactly that: torsos and heads, nodding on
stalks, grotesquely if whimsically unnatural. Above and around them twine
morning glories—a reminder that their artificial charms will not last the day. In
"'Winter'—A Skating Scene" (fig. 39), four healthy girls ranging in age from per-
haps six to sixteen skate with freedom and grace, their fashionable hoops tilting,
muffs, braids, and hat ribbons bobbing and streaming in the wind. And in "The
Morning Walk—Young Ladies' School Promenading the Avenue" (fig. 40) we
see a dapper, Homeresque man observing a procession of attractive and elabo-
rately attired young women.[14]

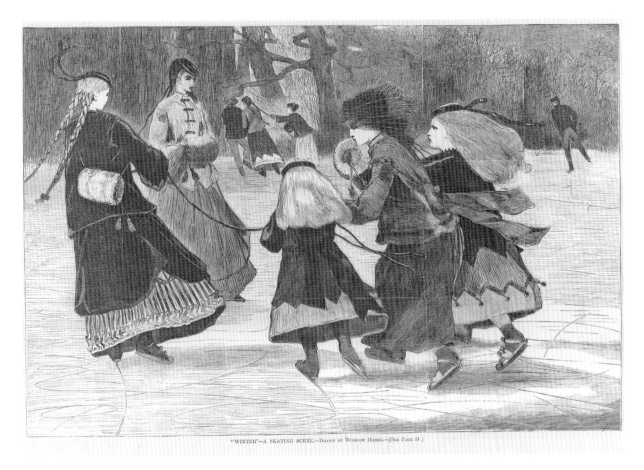

"WINTER"—A SKATING SCENE.—DRAWN BY WINSLOW HOMER.—[SEE PAGE 51.]

FIG. 39. Winslow Homer, "Winter—a Skating Scene," wood engraving, *Harper's Weekly*,
January 25, 1868. Bowdoin College Museum of Art, Brunswick, Maine,
Museum and College Purchase, Hamlin, Quinby, and Special Funds.

In "At the Spring: Saratoga" (fig. 41), Homer edged perilously close to carica-
ture in his delineation of the Girl of the Period type. Here the young woman in
the foreground, with her wad of hair, elaborate trimmings, high bustle, and tee-
tering heels, is the very embodiment of the much-derided Grecian Bend. At far
left is the figure of a girl less tightly trussed and more natural (relatively speaking),
with her hair loose under a simple straw hat. We see a similar contrast of types in
the painting *Long Branch, New Jersey* (fig. 42), where on the bluffs in the foreground
a young woman exhibits the same distorted profile as the one in the Saratoga
illustration. Indeed, save for the fact that she holds a lorgnette rather than a tum-
bler, this is the same figure. Several feet away stands the girl with the lost profile,
in ruffled white with blue ribbons and no bustle. She shades her face with a white

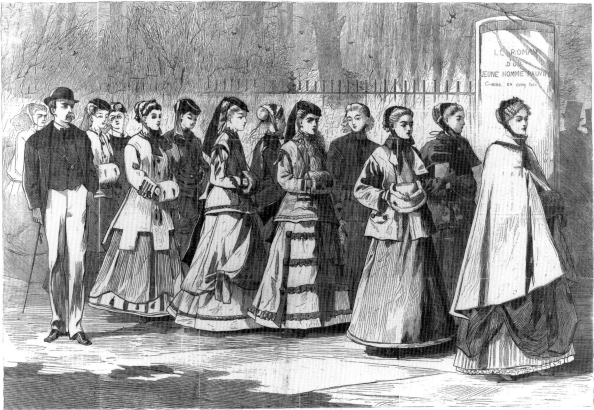

THE MORNING WALK—YOUNG LADIES' SCHOOL PROMENADING THE AVENUE.—Drawn by Winslow Homer.—[See Page 202.]

Fig. 40. Winslow Homer, "The Morning Walk—Young Ladies' School
Promenading the Avenue," wood engraving, *Harper's Weekly*, March 28, 1868.
Bowdoin College Museum of Art, Brunswick, Maine,
Museum and College Purchase, Hamlin, Quinby, and Special Funds.

parasol and has a tiny white dog on a leash. It may only be coincidence, but still worth noting that this young woman sports the colors—white and blue—that both Stowe and Alcott chose to symbolize the uncorrupted innocence of Pussy Willow and Polly.[15] Homer's girl of the Grecian Bend, by contrast, is in black and white, and the lining of her parasol and the plume of her hat are a vivid red.

These contrasts are subtle and might be dismissed as merely two points on a continuum of contemporary stylish excess. Yet more than once in the late 1860s, we see Homer's women in complementary or contrasting pairs. In *Croquet Scene* (fig. 43), a man stoops between the large, vibrantly hued figures of two women: one in blue and white, with an entire pheasant adorning her hat,

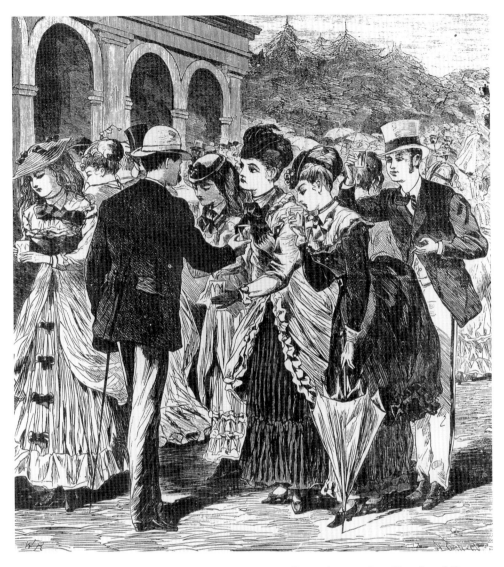

Fig. 41. Winslow Homer, "At the Spring, Saratoga," wood engraving, *Hearth and Home*, August 28, 1869. Indiana University Library, Bloomington.

and on the right an even gaudier figure in scarlet draped over a snowy hoop skirt. A third and more subdued woman in brown stands behind her. Evenly weighted, the blue girl and the red visually overpower the faceless man in his drab outfit of grays. His yellow straw boater prevents us from catching a glimpse of his features as he bends to the task of aligning two balls preparatory for the next move (during which one ball—presumably his—will be whacked out of bounds by his adversary).[16]

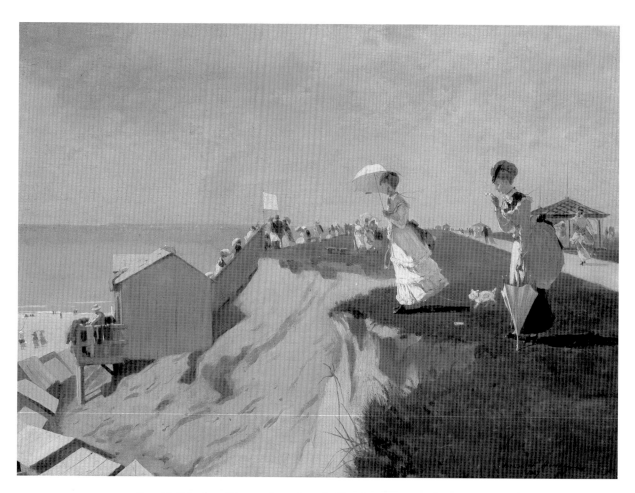

Fɪɢ. 42. Winslow Homer, *Long Branch, New Jersey*, 1869, oil on canvas,
16 x 21¾ in. (40.64 x 55.24 cm). Museum of Fine Arts, Boston,
The Hayden Collection—Charles Henry Hayden Fund 41.631.

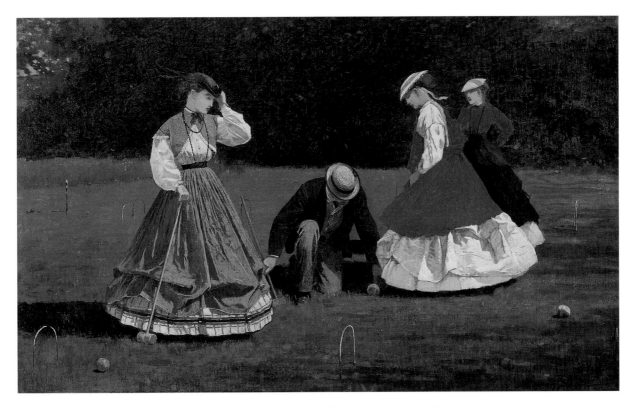

FIG. 43. Winslow Homer, *Croquet Scene*, 1866, oil on canvas, 15⅞ x 26⅟₁₆ in. (40.32 x 66.2 cm). The Art Institute of Chicago, Friends of American Art Collection, 1942.35.

Initially the painting seems a straightforward slice of modern life, showing the newly popular game of croquet, which allowed women and men to both compete and flirt on a level playing field. However, its visual design also encodes masculine unease over the new, public freedom of the postwar American girl. Trapped between those bulging hoops, the faceless man is visually pinned in place as well: the girls' hat brims generate vectors that angle down and intersect at the crown of his head. Is this man anybody, or nobody? Closer inspection yields one tantalizing clue: the man's moustache, stiff with wax and twirled into two flamboyant points, strikingly resembles Homer's own. Characteristically oblique, Homer plays his cards close to his chest, and there is no way to determine conclusively how much here is art and how much (if any) autobiography. But it is clear that the lone man in the picture is for all practical purposes *un*-manned and overpowered by modern femininity.

Homer's illustration "The Picnic Excursion" (fig. 44) incorporates a similar

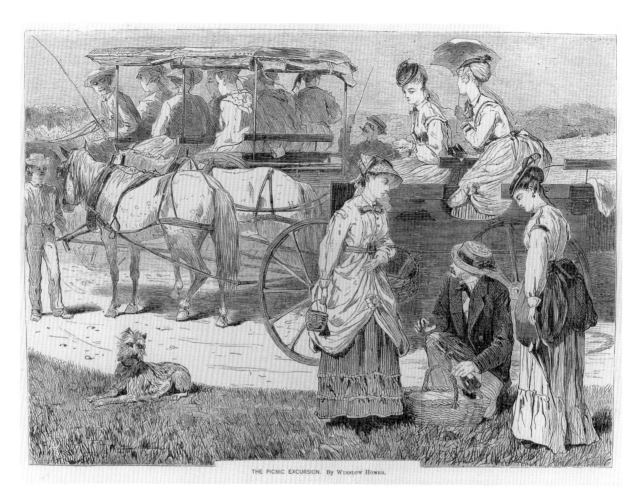

THE PICNIC EXCURSION. By WINSLOW HOMER.

FIG. 44. Winslow Homer, "The Picnic Excursion," wood engraving,
Appleton's Journal, August 14, 1869. Bowdoin College Museum of Art, Brunswick, Maine,
Museum Purchase, Elizabeth B. G. Hamlin Fund.

group, expediently recycled from *Croquet Scene*. Deviations from the original threesome, though, suggest additional, more elusive meanings. The scene bustles with activity. There are two wagonloads of young women, a couple of carthorses, a little boy, and a shaggy dog. At the right, a man with a moustache and a concealing hat brim stoops like the 1866 croquet player between two young women. As in the earlier scene, their gazes angle down to intersect at the crown of his head. The woman on the right, with her furled parasol and smartly tilted, feathered chapeau, is a milder version of the Girl of the Period in *Long Branch, New Jersey*. The one on the left is sartorially closer to the rider in *Bridle Path*. Her straw bonnet, indeed, is the same, her costume stylish but quieter

than that of her feathered friend. Rather than stoop passively between them, the man holds up a bottle of wine from the picnic basket and swivels his body toward his straw-bonneted companion. The angle of the bottle pointed in her direction reiterates his interest. The man with the moustache has chosen the softer and less aggressively modern type of the American girl.

This model of what Benson called "truly American" girlhood closely matches the pattern of what the historian Frances Cogan has identified as the ideology of "Real Womanhood," which from about 1840 to 1880 offered a viable alternative to the middle-class discourse of "True Womanhood" in circulation during the same period. Where the True Woman was delicate, passive, subservient, and self-sacrificing, the "Real Woman" was healthy, vigorous, and self-possessed. Proponents of this model emphasized the vital importance of bodily and mental exercise alike as essential training for the duties of womanhood. A fully developed liberal education was of particular benefit in equipping a young woman to choose the right mate, be a good mother, and become an effective household manager. Although in the abstract the concept of Real Womanhood contained feminist elements, these were, as Cogan points out, strictly confined within the larger framework of traditional values.[17] Both "ideals" were not much more than diagrams of what femininity should be, but they resonated, echoed, and re-echoed in print culture.

Eugene Benson's ruminations on the "Woman Question," for example, deplored the subjection of women not to oppressive patriarchal institutions but to the brutal grind of overwork. Their rightful mission was to beautify the home and make it a peaceful haven for men: "If we understood the woman question in its domestic and social aspects, we would labor to protect woman from the curse of work and the harassments of want; we would treat them as they treat flowers—with care, delicacy, and unfailing love; in our turn, we should be rewarded as they are rewarded by flowers—with a fragrant, delightful home atmosphere, with lovely textures, exquisite colors, beautiful forms."[18]

At the same time, the media endorsed certain new freedoms that women had gained. *Harper's Bazar* in 1871 lauded the success of public speakers such as

Kate Field and Anna Dickinson, and expressed great enthusiasm about the loosening of women's shackles and the opening of new avenues for work and intellectual development. Reformers kept up a running commentary about the importance of regular, vigorous exercise in the open air. Julius Wilcox exhorted women to hunt, boat, leap stiles on horseback, and walk five miles at a stretch. Such activities "may be dreadful things for women to engage in; but red blood, healthy lungs, and vigorous muscles would show Nature's opinion of them," he stated. And the healthy heroines of Stowe and Alcott earned praise for their forthright energy: they were in fact "far cleverer" than their male friends. "They are neither pert, nor fast, nor unfeminine, but they take the lead. . . . These young women are true-hearted, high-minded, and pure . . . wholesomely truthful, very sprightly, charmingly at their ease." Active agents rather than passive, bashful violets, they playfully and shrewdly dominated their society.[19]

The rider in Homer's *Bridle Path* exemplifies this new, sprightly type. Tracing a fine line between the old-fashioned girl and the Girl of the Period (or the Amazon), she has the virtues of the former combined with the modernity of the latter. Her white dress and blue ribbon connote her unsullied purity; her solo horseback ride symbolizes her active agency. "Delicate and sunny," to use Benson's words, and taking exactly the sort of "breezy, health-giving ride" recommended by advice givers, Homer's girl, at the very center of the world, seems independent and free. Yet is she? Through a subtle visual trick, Homer made it impossible to tell whether or not this modern, self-sufficient girl is holding the reins. Slack and swaying, they pass behind the cantle of the sidesaddle and disappear. The girl's cocked elbow and the position of her hand above the cantle would indicate that she is, or could be, holding them, but they are hidden from our eyes. Homer thus embeds a central, and crucial, ambiguity into the very heart of his composition. Is this all-American girl in control of her destiny, or will destiny control her instead? Is she riding toward liberation or entrapment? Is the man waving the handkerchief calling her back, urging her on, or warning of danger ahead? In these unresolved questions we sense the artist's own ambivalence toward his creation and her potential for self-determination.[20]

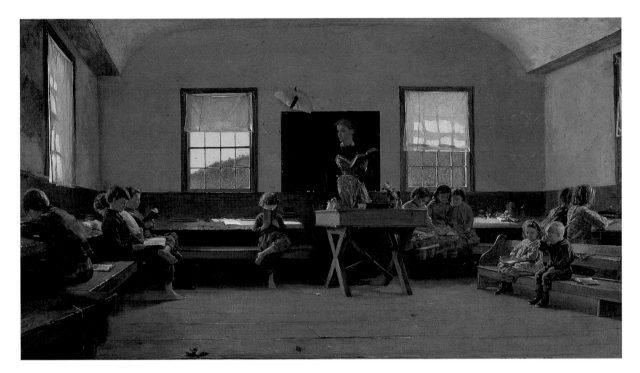

FIG. 45. Winslow Homer, *The Country School*, 1871, oil on canvas, 21¼ x 38¼ in. (54 x 97.2 cm) Saint Louis Art Museum. Museum Purchase.

Three years after completing *The Bridle Path* and one year after exhibiting it at the National Academy, Homer turned to the modern young woman's working life in *The Country School* (fig. 45), which he showed at the National Academy in 1872. Inside a one-room schoolhouse, a young schoolmarm holding a book stands behind a crude desk—little more than a box on trestles—and surveys her students, who occupy equally crude benches to either side. She stands just right of center before a blackboard symmetrically flanked by two windows that look out onto a sunny green hillside. The schoolteacher wears a plain black dress with white collar and cuffs and a white bib apron; a black ribbon holds back her neatly dressed hair. Dangling askew above the top left corner of the blackboard is her straw gypsy hat. On the desk before her are a hand-bell, a vase of cherry blossoms (symbolizing good education in the Victorian flower lexicon),[21] and a ponderous tome, perhaps a Bible. Sharply limned against flat blackness, her rosy face is pensive, her gaze inward. She is at once present and (mentally at least) absent.

Under her charge are six boys and six girls. On the long wall at left, four pre-

pubescent boys slouch as they peruse their textbooks; a fifth sits apart, nearest the teacher, his book (which looks like a *McGuffey's Reader*) hiding his face, a large hole in the knee of his pants. On the right are more decorous groups of little girls, working and reading together. Occupying a bench by themselves are the two youngest children: a girl and a boy, the latter rubbing one teary eye with his fist while his companion gives him a sidewise look of either consternation or concern. The room itself is gender-coded. On the boys' side, the notched and scarred wooden plank that serves as desk bears witness to many generations of pocketknives. On the girls' side, shiny lunch pails, cherry-blossom nosegays, and piles of books rest neatly in the corner; the wood, while scuffed, in better repair. The lone boy on the girls' side may be too young to sit across the room, or it may be that some infraction has landed him for punishment in humiliating female territory.

Homer's young schoolmarm might be the very type of modern American womanhood, independent, wage earning, working apart from the family circle in a very public sphere. Literate and self-possessed, she exercises unchallenged authority in the classroom. The art historian Nicolai Cikovsky has examined Homer's school subjects in depth, paying particular attention to the striking predominance of young women teachers in the post–Civil War classroom. Cikovsky ties the feminization of teaching to new theories of education, which stressed "instruction rather than punishment" and exalted women's "natural" capacity for nurture and kindly discipline to justify their fitness for teaching. Trained professionals, modern women teachers brought "competency, dignity, and a sense of vocation" to an occupation hitherto conducted by men more inclined to use the switch than to apply moral suasion.[22]

But the presence of women in the post–Civil War classroom was no novelty. The feminization of teaching had gotten under way much earlier. In the late 1830s, the reformer Horace Mann in Massachusetts spearheaded the movement to establish a democratic system of tax-supported common schools that would ensure basic education for all children. Both Mann and Catherine Beecher actively recruited women to the profession, arguing that by virtue of the qualities supposedly inherent to femininity, women were far better suited than men to

teach children, especially in the primary grades. As early as 1845, there were over two thousand more female than male teachers in the Massachusetts public schools, and as the population grew and the nation expanded, many thousands more were needed.[23] Women were thought to be gentle, maternal by nature. Unlike men, they did not aspire to the heights of achievement and fortune. They were religious and self-sacrificing; they had pure morals and clean habits. In sum, like the "True Women" on whom they were modeled, they were ideally equipped for the role of surrogate parent in the reformed schoolroom, seen by educators as an extension of the family circle.[24]

Although women far outnumbered men in the profession by the middle decades of the nineteenth century, they earned far less; in some cases as little as a quarter of what a man would be paid. Seemingly so independent and authoritative in the classroom, in actuality they lived under almost constant surveillance and to keep their jobs had to observe strict rules enforced by the local school board and church authorities. They often had to adopt curricula and textbooks chosen by the governing body. They seldom had their own private living quarters. Most often they boarded with families in the community, moving periodically from one house to another. They were expected to help with the housework and participate in domestic routines. Since they were supposed to be unimpeachable models of moral rectitude, they had to tread very carefully indeed; any infraction of local codes of conduct more than likely led to termination. Young women teachers were not allowed to marry, and marriage, which normally required them to resign, almost inevitably spelled the end of their careers. Sandra Fowler notes, for example, that "Connecticut's 1872 rules for teachers declared that women teachers 'who marry or engage in unseemly conduct will be dismissed.'" For many, teaching was but a way station on the road to marriage, but for some, it meant lifelong celibacy.[25] In exchange, women enjoyed at least a measure of independence, modest social status, and the rewards of a useful life.[26]

While many tended to both sentimentalize and idealize the teacher and her role as shaper of morals and minds, others—including, of course, teachers themselves—knew how difficult the work could be.

Only they know the strange isolation they endure, the heart-sickening lonesomeness they feel. . . . Let those who imagine this life in the school a pleasant one try it; and when the novelty has worn off, when each day becomes the counterpart of the preceding, when the mistakes that were amusing at first have become monotonous, when the interesting faces have lost their brightness poring over books too deep . . . they will readily admit that these and innumerable other petty annoyances require a teacher to possess her soul in patience. Talk about Job's patience! He never taught school.[27]

Often barely older than their pupils, teachers struggled with homesickness and insecurity. One, sixteen years old, wrote in her diary: "I cannot much longer repress these tears, and should [my students] see me weep, what can I tell them? How ridiculous the idea! A schoolma'am crying to go home."[28] Gail Hamilton, later a journalist, started out in the mid-1850s as a young teacher in Hartford, Connecticut. Although she was devoted to the job and committed to the welfare of her students, she complained of the unremitting labor: "I am so tired. I gave up entirely this morning. Sent my class out at half-past eleven, and had a cry. I am not sick, . . . but I am so tired, tired of learning lessons, tired of teaching them, tired of going to school at nine o'clock every day, tired of never visiting anybody, . . . tired of everything—almost."[29]

Who, then, is the teacher in Homer's *Country School*? Like the rider in *The Bridle Path,* she is an ambiguous figure. The central irony of Homer's representation lies in the fact that this young female—marriageable and fertile—is by strict regulation unmarried and childless. Yet her job requires her to act as surrogate parent and moral exemplar to other women's children. In this respect, Homer's teacher is comparable to the nursemaids that briefly interested him in the late 1860s and early 1870s; they too must tend children not their own.[30] The teacher's vacant stare suggests that her thoughts lie elsewhere. One hand, open, holds the open book; the other is a tense fist on the desktop. Between the book and the dangling hat is a kind of visual seesaw as well, the book connoting work and duty, the hat release from those imprisoning walls.

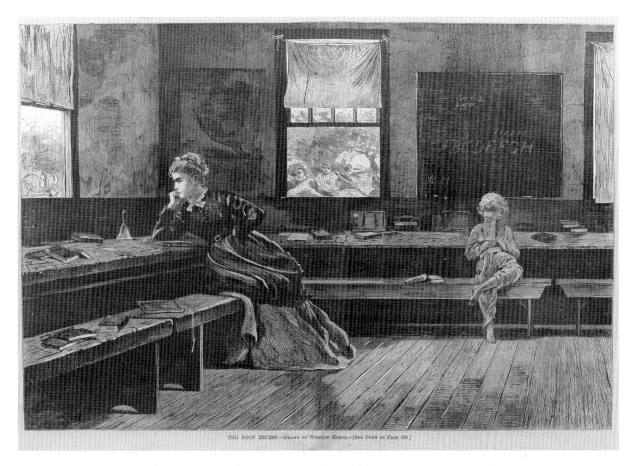

THE NOON RECESS.—Drawn by Winslow Homer.—[See Poem on Page 550.]

FIG. 46. Winslow Homer, "The Noon Recess," wood engraving, *Harper's Weekly*, June 28, 1873. Bowdoin College Museum of Art, Brunswick, Maine, Museum and College Purchase, Hamlin, Quinby, and Special Funds.

When Homer returned to the same schoolroom subject two years later, he made the implicit meanings of *The Country School* a great deal more explicit. In "The Noon Recess," a wood engraving published in *Harper's Weekly* (fig. 46), the teacher now slouches where the big boys sat in the earlier painting, hand to chin, staring moodily out of the window. All the children are playing outside, with the exception of the same little boy hiding his face behind his book. Presumably he is a miscreant whose punishment is to remain indoors. The teacher, though, must perforce endure the same confinement. On the wall directly above her head hangs a map of North and Central America, hinting at the wider world that she may long for but never see. In both the painting and the wood engraving, the teacher is an isolated figure. Unlike other artists, who represented

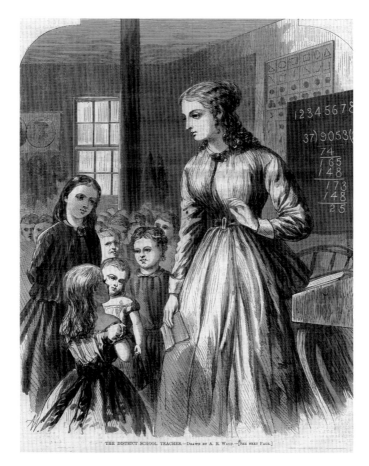

FIG. 47. Alfred R. Waud, "The District School Teacher,"
wood engraving, *Harper's Weekly,* November 9, 1867.
Indiana University Library, Bloomington.

teachers interacting with their young pupils (fig. 47), Homer chose to stress her
alienation.

In *The Country School,* the young teacher wears an apron with a heart-shaped
bib. *Harper's Bazar* early in 1871 published the illustration of a very similar apron
with pleated trim and a heart-shaped bib (fig. 48). Some aprons, embellished
with rich lace or embroidery, were purely fashionable, but others connoted do-
mestic, physical labor of some kind.[31] Designed specifically for the kitchen, the
apron in *Harper's Bazar* was of the latter sort. One can easily see that the school-
marm's apron has a purely practical value in protecting her black dress from
chalk smudges and other damage. But it is also an emblem of domestic and do-
mesticated young womanhood, badge of the working girl content in her own

KITCHEN APRON WITH PLEATED TRIMMING.
For pattern and description see Supplement, No. XIII
Figs. 54 and 55.

FIG. 48. "Kitchen Apron with Pleated Trimming,"
wood engraving, *Harper's Bazar*, March 11, 1871.
Indiana University Library, Bloomington.

sphere and posing no threat to masculine interests. The heart-shaped bib, like a lacy Valentine, suggests where the young teacher's thoughts might dwell.

Whether or not Homer observed and reported on a real country-school interior or made it up out of bits and pieces, it is a mix of old and new, nostalgia and modernity. The blackboard is modern; blackboards were relatively recent additions to the classroom, as were maps and other such paraphernalia. The backless wooden benches and bare plank desks, however, are anachronisms. Standard furnishing in the earlier district school, such benches, according to historian Michelle Cude, "were outmoded by the 1840s in favor of desks with seats attached."[32] Like the room itself, the teacher too is a mixture of old and new. Modern in her wage-earning independence but fashioned according to the older

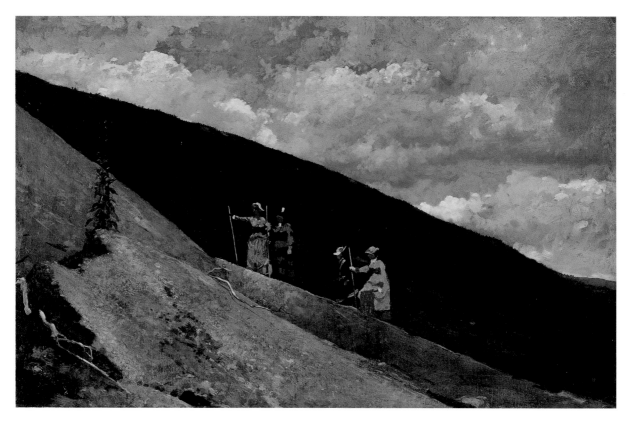

FIG. 49. Winslow Homer, *In the Mountains,* 1877, oil on canvas, 24 x 38 in. (61 x 96.5 cm).
Brooklyn Museum, Dick S. Ramsay Fund 32.1648.

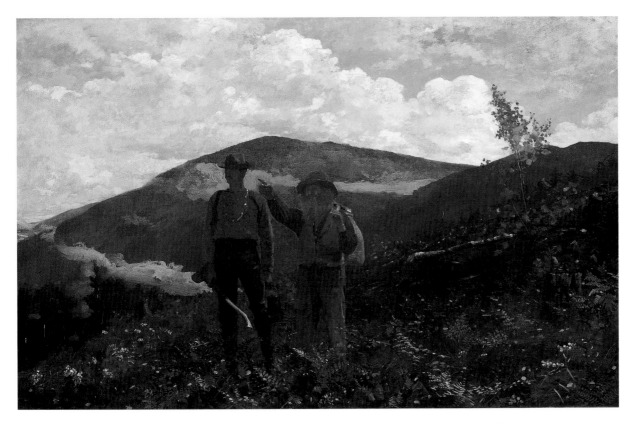

FIG. 50. Winslow Homer, *The Two Guides*, 1877, oil on canvas, 24¼ x 38¼ in.
(61.6 x 97.2 cm). 1955.3, Sterling and Francine Clark Art Institute, Williamstown, Mass.

model of the domestic, maternal female, she is poised on a threshold between past and future. Whether she will retreat or go forward is the question that the picture refuses to answer.

The four women tramping uphill in Homer's *In the Mountains* (fig. 49), however, are heading in one direction. Unlike the croquet players or the swimmers of *Eagle Head,* unlike the schoolteacher bounded by the schoolhouse walls, these hikers move through a stern and even forbidding wilderness. Roughly equivalent to *The Bridle Path* in size and subject, this painting moves women out into a much more rugged terrain than the populous peaks of Mount Washington. They are halfway up a slope that rises steeply from bottom right to top left. Apart from one stunted pine, the landscape is a desolate waste of bare brown rock and dead roots. The ridge behind the women is dead black, although patches of blue break through the clouded sky above. The women toil purpose-

fully upward, the pair in front looking back as if to check the progress of the pair behind. They wear plain walking dresses in subdued blue or gray enlivened with touches of scarlet, the bright red underskirt of the rearmost hiker a visual exclamation point amid the bleak expanse of somber tones. Shaded by broad hat-brims, their faces are too far away to decipher; we must rely on body language to tell us that these four figures are full of confident vigor, the leader with staff thrust out at arm's length and pointing the way to the unseen summit.

Although the title does not specify, Homer's women are probably above Keene Valley in the Adirondacks, climbing the slope to Mount Marcy or another of the high peaks in that vicinity.[33] In the summer of 1877, Homer made his third visit to the Adirondacks, collecting material and ideas for paintings. Like *In the Mountains, The Two Guides* (fig. 50) was a product of that trip, but unlike the former, it features a pair of rugged men alone among the peaks, the grizzled elder pointing something out to the younger, a handsome figure in a bright red fireman's shirt. The two paintings, nearly identical in size, are pendants representing two very different sides of the same wilderness, rigidly divided (like the schoolmarm's classroom) along gendered lines.[34]

Such divisions came more and more to characterize Homer's work from the late 1870s to the end of his life. Whereas in his earlier work, young men and women socialize, dance together, and flirt, in the later work men and women increasingly inhabit separate (and often adamantly antimodern) worlds of work and play. After 1877, Homer's Adirondacks and all his other wilderness scenes represent woods, mountains, and lakes as entirely and exclusively masculine preserves.

Artists, hunters, and campers had long been familiar with Adirondacks haunts, but the Reverend William Murray's popular *Adventures in the Wilderness* instigated a "rush" to the region in 1870.[35] That rush in turn spawned a minor industry devoted to Adirondacks tourism: resort hotels, camping facilities, guides, and guidebooks proliferated. With few exceptions, guidebooks and other travel narratives portrayed the mountains as the realm of masculine adventure. The illustrations in Edwin R. Wallace's *Descriptive Guide to the Adirondacks,* for example, depict men only, engaging in various wilderness sports and activities. For H.

Perry Smith in *Modern Babes in the Wood,* women on the trail or in the camps were so astonishing a sight as to merit the exclamation, "A Woman, by Jove," in the table of contents.[36]

The new resorts, however, were enclaves of femininity. Commodious hotels such as the Ondawa at Schroon Lake offered a croquet park, a billiard hall, and a brass and quadrille band. Male and female invalids alike also repaired to the mountains in search of relief from tuberculosis. By some unspoken compact, women were expected not to stray from their designated, safe havens. But more than a few hardy women scorned the comforts and luxuries of the hotels and enthusiastically embarked on the quest for authentic experience in the wilderness.

Queen Victoria's maid of honor Amelia Murray—at sixty—roamed the Adirondacks in 1855. She camped out in the woods, broiled freshly caught trout for breakfast, and sampled other novelties of primitive life (softened by inflatable cushions and other civilized amenities). In 1874 Sarah Goodyear camped with her husband and guides for ten days at Little Round Lake in Hamilton County, New York, and published a narrative of her experiences. Those included a bit of fly-fishing although for the most part she played a passive role, enjoying the scenery and waiting for the men to bag some game for dinner.[37]

Other women sought much more rigorous experiences. For Kate Field, the flamboyant journalist and public speaker, the wilderness promised liberation from the tyranny of fashion and convention. Inspired by Murray, Field undertook a camping expedition in the Adirondacks in the summer of 1870. She contemptuously dismissed the pampered city women she encountered at the lodge before setting out for the woods: "they flaunt their muslins in the face of the backwoodsman, and hover on the outskirts of the wilderness, as if to say to their sex, 'so far shalt thou go and no farther.'" Field, by contrast, embraced the opportunity to strip away all encumbrances and dash into the wild: "Helter skelter, off with silks, kid gloves, and linen collars, on with bloomer, stout boots, and felt hat, and we helpless women are transformed into helpful human beings. . . . 'You are maniacs,' cry women in muslin, who stand upon the pier to wonder at our madness as we glide away from our 'kind' and are at last on Adirondack waters."

In the woods, Field explored, fished, hunted, and climbed "every mountain

within reach," to see "such glorious expanses of lake and mountain as make us silently worshipful." Since the Reverend Murray failed to advise women on gear and clothing, Field gave detailed advice on the wilderness trousseau, which included such items as flannel underwear, a waterproof, and a gentleman's felt hat with a broad brim. She exhorted women to plunge into wilderness adventure for the sake of their health although she doubted that most had the physical and mental fiber to tough it out. "They go mad over the biting of mosquitoes, but accept an attack of diphtheria at Saratoga without complaint. They deride a bloomer dress, in which every muscle has full play, and drag unwholesome fashions through the street and parlor with infinite satisfaction." But women who were willing to be tanned and freckled, and to expand their lungs and enlarge their waists, would renew both health and youth in wilderness adventure.[38]

Although the climbers in Homer's *In the Mountains* wear skirts rather than bloomer costumes, they are neither flaunting their muslins nor hovering on the outskirts of the wilderness. They are far from home and on their own. The Homer scholar David Tatham notes with good reason that it is "hard to think of any American painter before [Homer] who would have presented four women hiking for pleasure on a mountain trail unaccompanied by men."[39] We have only to compare the "Ascent of Mount Marcy" (fig. 51) by T. Addison Richards to gauge the subversive novelty of Homer's vision. In Richards's illustration, published about eighteen years previous to *In the Mountains,* a party of six men and four women toils upward in a straggling line. Prominent in the foreground is a group of three: two men aiding a young woman, one pulling her along by the hand and the other pushing, his hand at her waist. Another woman tries to help herself by grasping an overhanging branch. All the men have staffs, but none of the women do. Homer's four climbers, by contrast, wield their own staffs and stride rather than stumble as they march steadily higher.

Who are these determined climbers? No record remains to tell us whether Homer encountered them one day in the mountains, or invented the scene. There is a drawing of the four figures (in a private collection) seen from a closer vantage point, but again, we do not know if Homer posed them, or if they were strangers passing, hastily sketched. The very fact that they hike for leisure marks them as

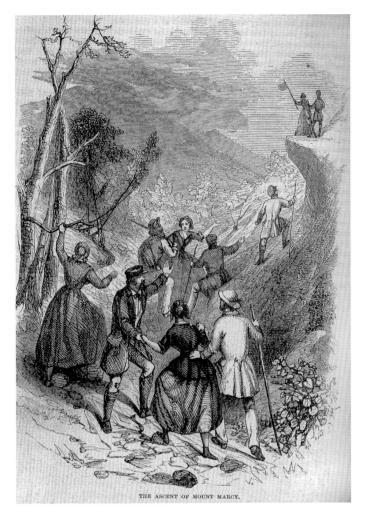

FIG. 51. T. Addison Richards, "Ascent of Mount Marcy,"
Harper's Monthly, September 1859.
Indiana University Library, Bloomington.

outsiders. Nonetheless, they act very much as if they belong, and the mountain belongs to them. What is the meaning of their presence in the wilderness?

Homer left a clue in a related work, *Beaver Mountain, Adirondacks; Minerva, New York* (fig. 52), which Tatham dates circa 1874–1877. At the center of this composition are two young women, one in close-fitting gray with touches of red, the other in navy, both wearing wide-brimmed and rather dashing hats. They exchange glances as the one in gray points aloft, her hand elegantly gloved in black. She carries a bulky sack on a strap slung across her body from one shoulder. The day is sunny; the two stand knee-deep in scrub. Behind them is

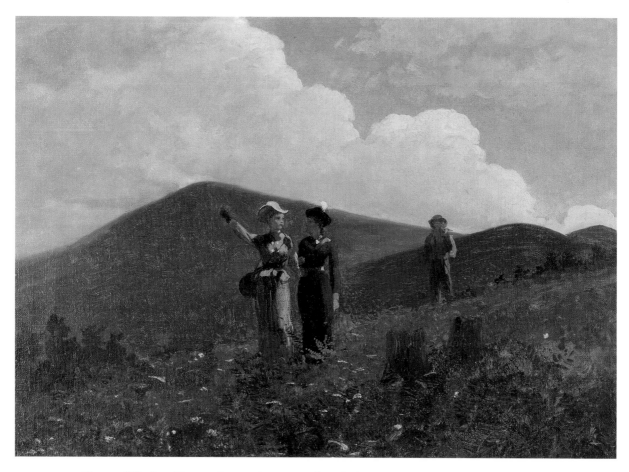

FIG. 52. Winslow Homer, *Beaver Mountain, Adirondacks; Minerva, New York*, ca. 1874–1877, oil on canvas, 12⅛ x 17⅛ in. (30.8 x 43.5 cm).
The Newark Museum, Purchase 1955 Louis B. Bamberger Bequest Fund 55.118.

the distinctive conical silhouette of the mountain, and one more figure, whose bushy beard identifies him as Orson Phelps, a local character and guide celebrated in many a handbook for his wilderness knowledge, woodsman's skills, and salty wisdom. Yet he seems to have nothing to do. The women lead the way, point out the sights to each other, and even carry the gear. Phelps, in drab browns and standing at a distance, is superfluous.

Since Homer used Phelps as a model in other works (including *The Two Guides*) it is safe to assume that he had a good sense of the garrulous Phelps's ideas and opinions. The novelist and editor Charles Dudley Warner devoted several detailed pages of description and anecdote to Phelps in his Adirondacks narrative, *In the Wilderness,* first published in 1876. Warner wrote that Phelps

had no use for flippant city slickers who failed to appreciate his beloved woods and hills. Once, on a descent from the stark summit of Mount Marcy, Phelps regaled Warner's party with the story of

> a party of ladies he once led to the top of the mountain on a still day who began immediately to talk about the fashions! As he related the scene, stopping and facing us in the trail, his mild, far-in eyes came to the front, and his voice rose with his language to a kind of scream.
>
> "Why, there they were, right before the greatest view they ever *saw,* talkin' about the *fashions!*"
>
> Impossible to convey the accent of contempt in which he pronounced the word "fashions," and then added, with a sort of regretful bitterness—
>
> "I was a great mind to come down and leave 'em here."[40]

We cannot know if Warner's anecdote has any direct or even indirect bearing on the connotations of the scene in *Beaver Mountain.* Yet the story suggests a subtext for Homer's painting, having to do with male ambivalence and even hostility toward female intrusion into the wilderness, and the collision of urban mores (coded as female) with those of the pure, primitive nature (coded as masculine turf). In *Beaver Mountain,* Phelps's physical distance from his two feminine clients enables us to take the measure of his calculated *mental* distance from the spectacle of the self-sufficient female at home in what should be no woman's land.

Homer wiped out all trace of women when he painted *The Two Guides.* Side by side and of one mind, Phelps and handsome Monroe Holt stake their claim as authentic denizens of these uncivilized and barren heights. If we read *In the Mountains* as a pendant, we can take the measure of Homer's ambivalence as well. The four sturdy hikers—modern, independent, self-guided females—are not simply outsiders but invaders. They may or may not be talking of "the fashions," but they are clearly out of place. The looming black ridge behind them suggests that they will find no welcome here. Yet Homer's representation of

these strong, determined, healthy women—climbing higher and higher—suggests admiration and respect, however much he himself may keep his distance. These women are on no bridal path but one of their own choosing. In this respect, they are truly New Women, for all the artist's ambivalence about their presence here.[41] No longer girls, they are on their way into an unknown but surely challenging future.

THE MANLY NEW WOMAN

❧

MARY W. BLANCHARD

Throughout most of the nineteenth century, the ideal Victorian woman was described as a loving homemaker and mother, a submissive, gentle, and genteel lady. Yet by the end of the century this intriguing statement appeared: "Every woman is at heart a barbarian. . . . There is something alluring in the idea that the prehistoric woman and Madame Nowadays are united . . . in a community of sensation."[1] How can we explain this fascinating change?

The "barbarian" in Madame Nowadays incorporated Darwinian notions of evolution, for, as the author explained: "After centuries of motherhood, woman . . . is beginning to be simply—woman."[2] But Madame Nowadays also mirrored the controversy over a new phenomenon, the emancipated New Woman, who became so visible by the 1890s. On one side of this debate stood the New Woman, the suffragette or the educated professional who, though assertive, remained within the dictates of proper Victorian behavior. She dressed in conventional clothes and often led a respectable life as wife and mother. She might be labeled "a barbarian," but she had many supporters.

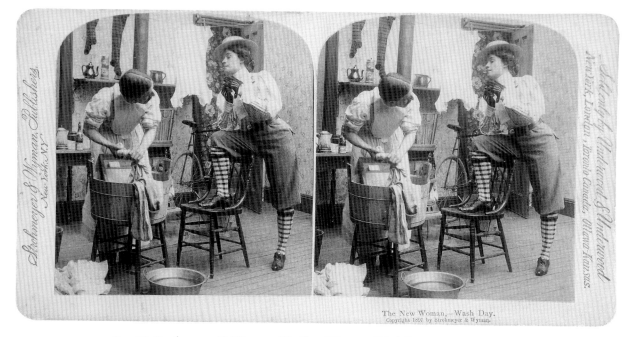

FIG. 53. Strohmeyer & Wyman, *The New Woman—Wash Day,* 1897, stereoview.
Catherine Smith Collection.

Others, however, detected a new side to Madame Nowadays: the manly
New Woman. The manly woman often appeared wearing pants. She delighted
in upsetting the status quo by smoking and bossing her husband (fig. 53).
Often, she did not want to marry or have children. Rather, she craved sensa-
tion. As one critic scolded, she was "mannish and brusque, and given to horse-
play and lounging and smoking with men."³ In the contemporary press,
illustrations such as "In a Twentieth Century Club" (fig. 54) exemplified the
outrage (and caustic humor) directed toward women aping the "sporting life"
of men's clubs. Most disturbing in this illustration was the male dancer per-
forming in a ballet dress. Was this manly woman of the 1890s emasculating the
Victorian man?

Not everyone, however, sensed disorder. The *National Police Gazette,* for in-
stance, applauded the manly exploits of women, and suggested a female subcul-
ture of erotic behavior and defiant cross-dressing. These titillating reports
showed that the strident denunciations of the manly woman that appeared in

FIG. 54. "In a Twentieth Century Club," *Life*, June 13, 1895.
Rutgers, The State University of New Jersey Library, New Brunswick.

some mainstream publications (she was a vampire, a beast, perverse and dangerous) were not the only response in society.

Women in pants who appeared in the *Gazette* might appeal to the prurient male, but spoofs of emancipated manly women (fig. 55) and somber assessments of "In Days to Come" (a dead woman on the battlefield) (fig. 56) suggested how complex gender issues really were. Victorians might laugh at the manly woman in society, but the far-ranging implications of women acting as men could be disturbing. Complicated, too, was the issue of lesbianism that was closely connected to women who opted out of a conventional life of marriage

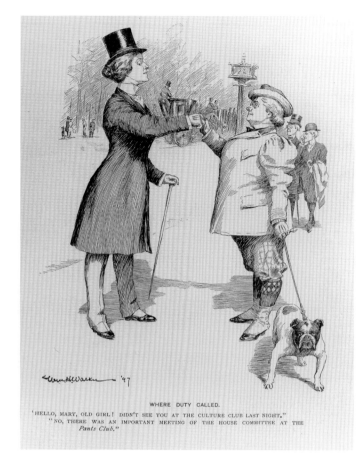

WHERE DUTY CALLED.

"HELLO, MARY, OLD GIRL! DIDN'T SEE YOU AT THE CULTURE CLUB LAST NIGHT."
"NO, THERE WAS AN IMPORTANT MEETING OF THE HOUSE COMMITTEE AT THE
Pants Club."

FIG. 55. William H. Walker, "Where Duty Called," *Life*,
March 25, 1897. Rutgers, The State University
of New Jersey Library, New Brunswick.

and children and lived openly together, with one partner wearing the symbolic
"pants," that is, the "Boston marriage."

The manly New Woman reflected an awareness of changes that would de-
velop in the next century. Women's choice of gender roles, whether from male
or female models, would be a force for a new age. It would recast women in
many new roles, breaking nineteenth-century stereotypes and allowing women
to decide their own destinies. The story of the manly woman in Victorian soci-
ety began before the Civil War. It is a narrative that blends both the private and
public worlds and examines the elusive boundaries between the male and the fe-
male spheres.

❧

Fig. 56. "In Days to Come," *Life*, December 3, 1896. Library of Congress.

The origin of this manly New Woman dates from mid-century. Critics complained that overbearing women were becoming too public and too political; they were, in short, too manly. Yet, at the same time, a new trend began in the private realm: some Victorian women started to wear fashionable Oriental pants at home. Likewise, women at spas, asylums, or sanatoriums often wore a combination of masculine Turkish trousers and pantalettes. A bifurcated gym suit was worn for athletics at most of the newly founded women's colleges, "very attractive costumes for the always healthful, now popular gymnastics" (fig. 57). In private, manly costumes were acceptable, but in public, male attire was often censured.[4]

Women's bathing costumes, for instance, often pants and a tunic, were barely tolerated by startled Victorians who viewed the suits as shocking and provocative (fig. 58). Yet many other women, particularly in the West, wore pants as a practical matter with little outcry. Photographs of women in trousers

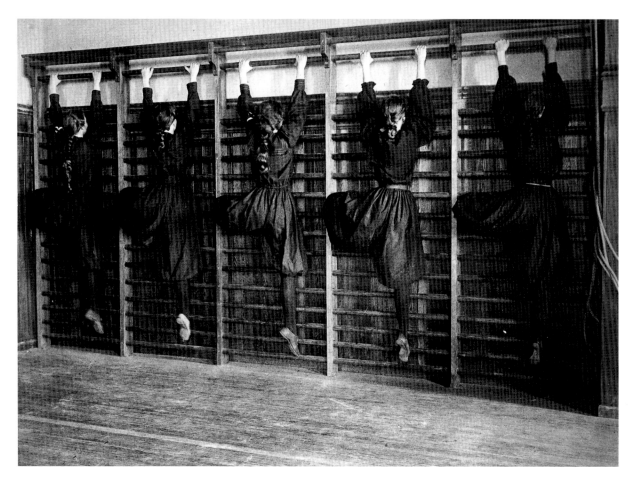

Fig. 57. Frances Benjamin Johnston, *Gym Class, Western High School, Washington, D.C.*, 1899, photograph. Library of Congress.

as farm laborers (fig. 59), ranchers, miners, lumberjacks, and house painters showed that men's wear was often worn as a sensible working outfit. In the 1870s, magazine writers made a celebrity of Martha Jane "Calamity Jane" Cannary, who dressed in breeches most of her life. This sharpshooter and horsewoman served as an Army scout in the West and performed in Buffalo Bill Cody's *Wild West Show* (fig. 60). As well, women on the Overland Trail often wore pants when traveling. One trekker described her "full bloomer pants, fastened at the knee, [worn with] high laced boots and . . . white stockings which were changed often enough to be kept spotless."[5]

Bloomers were part of the dress reform movement spawned from many utopian societies that existed in the United States before the Civil War. Charis-

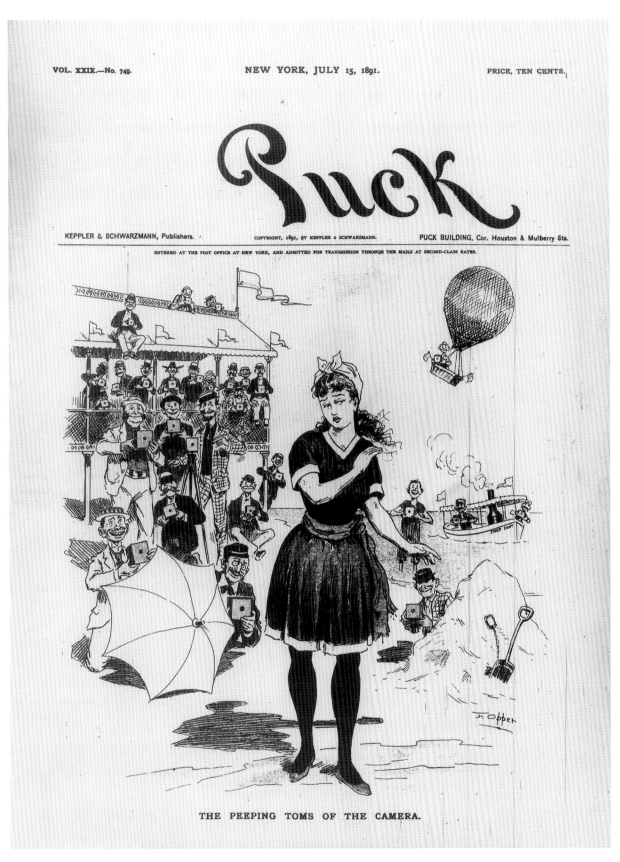

Fig. 58. F. Opper, "The Peeping Toms of the Camera," wood engraving,
Puck, July 15, 1891. Library of Congress.

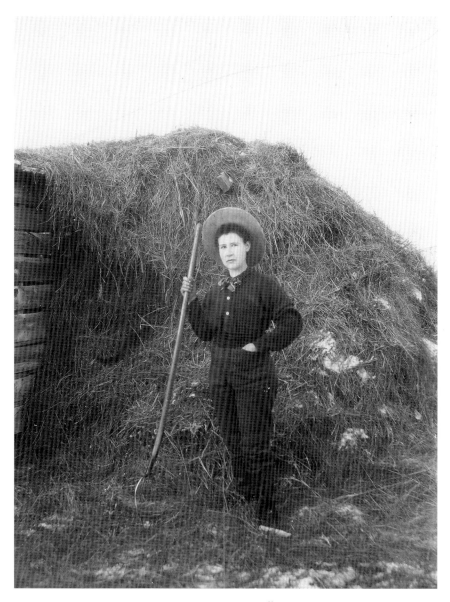

Fig. 59. *Woman Farmer*, 1890, albumen print.
Catherine Smith Collection.

matic cult leaders who endorsed manly costumes for women followers some-
times had a misogynist agenda. Robert Dale Owen, who organized New Har-
mony (1824), a socialist community in Indiana, coerced some women to wear a
trousered uniform. In the 1840s, John Humphrey Noyes founded the Oneida
Community in western New York. Believing in biblical Perfectionism, Noyes
often confiscated jewelry ("Eve's sin"), and dictated pantalettes and short,

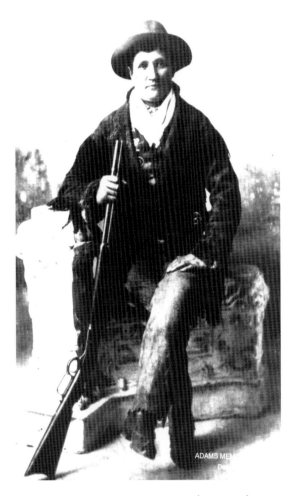

FIG. 60. *Calamity Jane*, 1876, photograph.
Courtesy of the Adams Museum & House,
Deadwood, S.D.

cropped hair for women (fig. 61). More bizarre was the utopian Beaver Island Kingdom founded by James Jesse Strang, a Mormon. Strang ordered women to wear bloomers (those who did not comply were whipped, along with their husbands) and dressed his young wife in men's clothing.[6]

Thus, the utopian communities' use of manly dress complicated the story of the first public wearing of the bloomer costume in 1851 by Amelia Bloomer, feminist and editor of the *Lily,* a journal championing temperance and women's rights (fig. 62). Utopian leaders used dress codes in part to control their closed communities. But the leaders of the suffrage movement wore the bifurcated

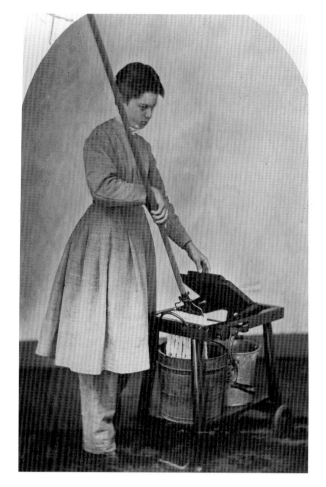

Fig. 61. *Oneida Community Woman (Anna Bolles)*
in Pantalettes with OC Patented Mop Wringer,
ca. 1860, photograph. From the Collection the
Oneida Community Mansion House, Oneida, N.Y.

dress to challenge the nineteenth-century gender system. Some reformers felt that women who wore pants were a symbolic example of women's equality in society. Clothes became a public and political statement. However, Elizabeth Cady Stanton and others who wore the bloomer costume eventually discarded the Turkish trousers when public reaction became too hostile over the "unmentionable" male pantaloons.[7]

A surprising number of women dressed in pantaloons or trousers to serve in the Civil War. The *vivandières* were mascots, nurses, and even fighters with both Confederate and Union regiments. Often dressed in a costume of pants and a

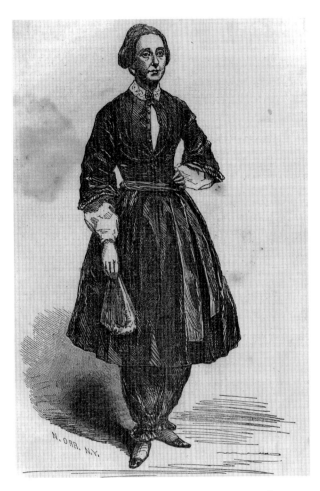

Fig. 62. N. Orr, "The American Costume"
(Amelia Jenks Bloomer), *The Water-Cure Journal*,
October 1851. Rutgers, The State University
of New Jersey Library, New Brunswick.

military jacket, these women were attached to regiments organized as independent companies of troops. They often served with the colorful Zouave militia, soldiers who adopted the French uniform that consisted of baggy trousers and short collarless jackets.[8]

Mary Tepe, nicknamed "French Mary," (fig. 63) was the most widely known *vivandière*. She sold contraband whiskey and other goods to the soldiers, served hospital duty, and helped the men with cooking, sewing, and washing. Coming under fire many times, she always carried a pistol and eventually was awarded the Kearny Cross for bravery. French Mary was remembered as always gay,

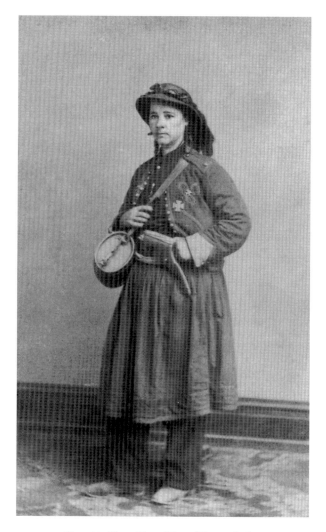

FIG. 63. *Mary Tepe, Vivandièrs with the*
114th Pennsylvania during the Civil War,
1860s, albumen print. Collection of Greg French.

"laughing and pointing very unconcernedly, as she stumbled over axes, spades and other obstacles, on her way to the trench!"[9]

If French Mary carried a pistol and crouched in trenches, she was not a regular soldier. There are, however, numerous accounts of females disguised as actual fighting men. Estimates range that from five hundred to one thousand women cross-dressed, fought, and even died during the conflict. One soldier was Sarah Rosetta Wakeman (fig. 64). In 1862, Sarah left the family farm in New York, disguised herself as a man, Lyons Wakeman, and enlisted. Among her feats, she

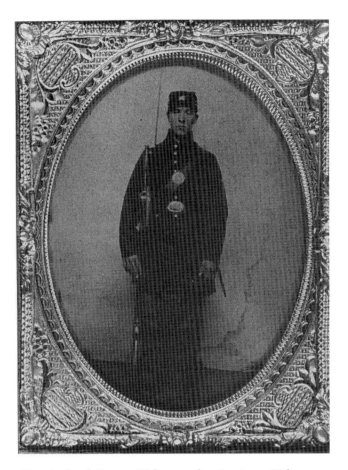

Fig. 64. *Sarah Rosetta Wakeman, alias Pvt. Lyons Wakeman,*
153rd Regiment, New York State Volunteers,
ca. 1862, photograph. Private collection.
Courtesy of the MINERVA Center, Pasadena, Md.

wrote that she "layed" all night on the battlefield among the dead and dying. In 1864, she contracted chronic diarrhea and died on June 19 at the age of twenty. As a soldier, her true identity was never discovered and she was buried as Lyons Wakeman at the Chalmette National Cemetery near New Orleans.[10]

Another female soldier was Jennie Hodgers. In 1862, Jennie enlisted as Albert D. J. Cashier and served with General Ulysses Grant's Army of Tennessee. Eventually captured, Cashier knocked her Confederate guard down with his rifle and fled to Union lines. In 1865 when the regiment was mustered out, no one had suspected Cashier's true identity. She was eventually discovered to be a woman. But when she died at seventy-two on October 11, 1915, she was buried

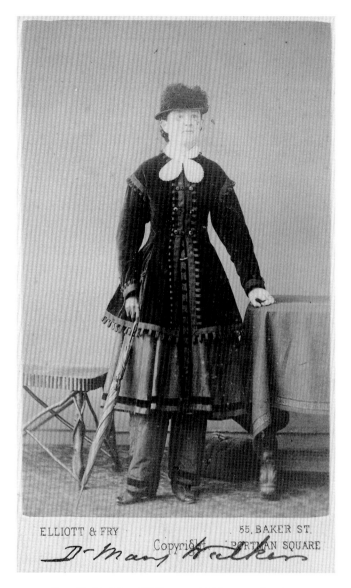

ELLIOTT & FRY 55, BAKER ST.
 Copyright PORTMAN SQUARE
 Dr. Mary Walker

FIG. 65. *Dr. Mary Walker*, ca. 1866, carte-de-viste.
Catherine Smith Collection.

in her Civil War uniform with full military honors. The original gravestone at the cemetery read "Albert D. J. Cashier Co. G 95th Ill. INF."[11]

Another woman who dressed as a man was Dr. Mary Edwards Walker, a contract-surgeon who served the U.S. government in the Civil War. Walker never disguised her sex, but dressed exclusively in men's clothes all her life (fig. 65). During the war, Walker was captured and sent to prison until 1864. Wrote a Confederate officer, "We were all amused and disgusted too at sight of a thing that

nothing but a debased and depraved Yankee nation could produce—a Female Doctor."[12]

After the war, her manly attire brought on continuing hostility: she was pelted with rotten eggs, set upon by dogs, and followed by "rowdies who were anxious to get a glimpse of her peculiar attire." Lecturing in Europe and America added little income to her meager medical practice. Eventually in her old age, she appeared in men's clothing as a sideshow spectacle. There was "something grotesque in her appearance on a stage built for freaks" commented a Buffalo, New York, paper in 1893. Thus, to late Victorian Americans, manly women caused considerable consternation when cross-dressed in public. Walker's eccentric life and masculine outfits were suggestive of deeper anxieties. The manly woman carried a suggestion of deviance.[13]

Deviance could be viewed in many forms. Another threat was the woman who behaved like a man in the public marketplace, one who had no regard for conventional mores. Victoria Claflin Woodhull, a fiery advocate of free love, broke all the molds. In her youth, she toured with her eccentric family as a clairvoyant and healer (a "cancer infirmary" was established in Ottawa, Illinois, where one patient died under treatment). Moving on, the traveling troupe then sold a Magnetic Elixir and, using Victoria's sister Tennie C. Claflin as a medium, told fortunes and communed with the dead. On tour, there were always rumors that the two beautiful sisters arranged rooms for assignations in their houses and even serviced some of the clients themselves. Highly visible, the family prospered with their seances, blackmail schemes, and publicity stunts (a brass band heralded their arrival in Chicago, for instance).[14]

Soon Victoria Woodhull was appearing on stage as a spokesperson for free love. Of marked intelligence and beauty, Victoria, on the platform, "dressed in plain black, with flushed face, gleaming eye, locks partly disheveled, upraised arm and quivering under the fire of her own rhapsody" advocated sexual freedom for women. "Yes, I am a free lover!" thundered Woodhull in one lecture November 22, 1871, "I have an inalienable, constitutional, and natural right to love whom I may . . . to change that love every day if I please!"[15] Respectable Victorians were horrified. Thomas Nast satirized Woodhull as Mrs. Satan carrying a

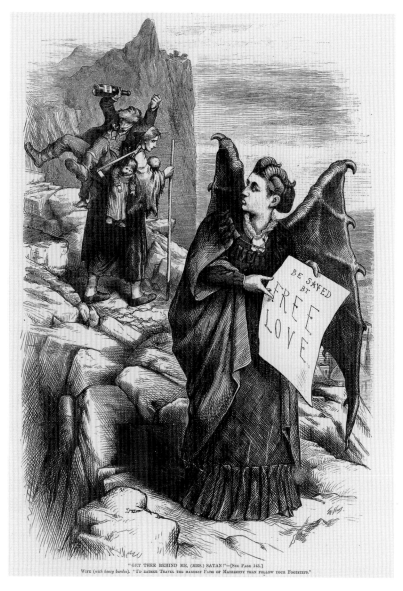

FIG. 66. Thomas Nast. "Get Thee Behind Me, (Mrs.) Satan!"
wood engraving. *Harper's Weekly*, February 17, 1872. Library of Congress.

banner "Be Saved by Free Love" in *Harper's Weekly Magazine* on February 17, 1872
(fig. 66).

By 1872, Woodhull, from her modest beginnings, had made a fortune on the
stock market, had campaigned for women's suffrage, and had testified before
Congress. On February 14, 1870, with cropped hair and dressed in men's cloth-
ing (fig. 67), the two sisters had opened the first women's brokerage house,
Woodhull, Claflin & Co. Victoria proudly announced that "while others argued

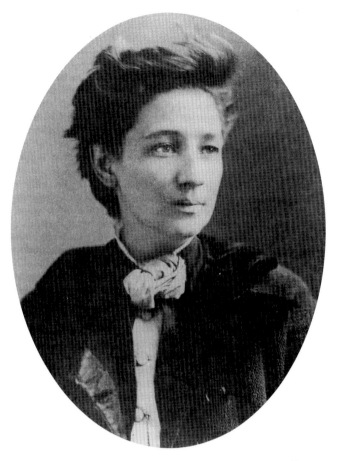

FIG. 67. *Victoria Woodhull*, 1871, photograph. Private collection.

the equality of woman with man, I proved it by successfully engaging in busi-
ness . . . I now announce myself as candidate for the Presidency." This challenge
to the male role in dress, business, and politics brought reaction: Woodhull was
a "fast" woman with an improper past; her "brazen immodesty . . . has pro-
claimed her as a vain, immodest, unsexed woman," moralists warned.[16]

The ambivalence over Woodhull as a manly, unsexed woman did not extend
to another performer who captivated audiences in her guise as a man. Lotta
Crabtree (fig. 68) began her career at six years old, performing in the mining
camps of the Sierras. Her mother carefully hoarded all the gold coins showered
on this tiny, red-haired performer, buying up real estate and making a fortune.
Lotta appeared in the vaudeville houses of San Francisco and ended up the belle
of Broadway. She often played manly roles, swore on stage ("She says 'Damn it!'

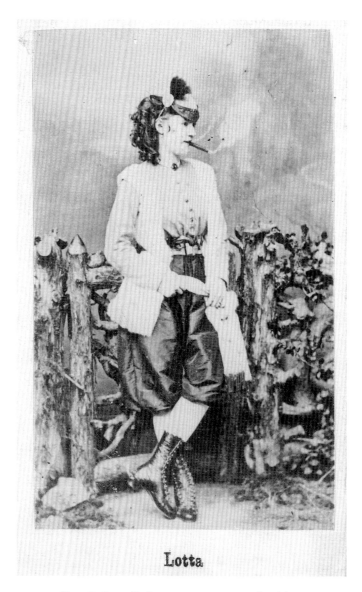

Lotta

FIG. 68. *Lotta Crabtree*, ca. 1870, carte-de-visite.
Catherine Smith Collection.

with spirit and gusto," applauded one critic) and wore male clothes on stage and off. Known for smoking thinly rolled black cigars, the "eternal child" never married. From her humble start, Lotta died a multimillionaire at seventy-six, leaving the bulk of her estate to veterans, aging actors, and animals.[17]

Thus the story of the manly New Woman in the last decades of the nineteenth century carried a mixed message. In private, Victorian women who wore pantaloons were not considered deviant. But openly female personalities who

FIG. 69. Harry Whitney McVickar, "A.D. 1900," from *The Evolution of Woman* (New York: Harper & Brothers Publishers, 1896). The Newark Museum.

stepped into male roles (Dr. Mary Walker or Victoria Woodhull) were criticized. Wearing the pants meant a lot more than a fashion statement. It meant a contest of who had power in society. More dangerous, manly women, it was believed, sided with the forces of cultural anarchy and degeneration that were appearing in Anglo-American culture in the late nineteenth century.[18]

Fear of strong females surfaced in attacks on manly women. Humor often diffused anxiety (fig. 69), but the concern was widespread and real. Male voices

warned that this "tailor-made" woman produced "decadence" in poetry. She was a "usurper of man's sphere [who] cannot reason abstractly, neither can she reason exactly." Another writer pronounced, "There is a peculiar neurotic condition called hysterical which is ingrafted on the organization of woman . . . a potentiality for irregular, illogical, incongruous conduct."[19]

Physicians labeled these manly women as dysfunctional and lesbian. In 1883, a St. Louis medical journal reported on a "Case of Sexual Perversion," Lucy Ann Slater, alias Rev. Joseph Lobdell. "Her features were masculine. She was dressed in male attire . . . and is indecent & immoral." A Dr. Edward C. Mann warned that "dementia and death is generally the end of these cases." Urgency over these conditions led doctors to recommend cold baths and even the removal of the ovaries. Wrote Dr. F. E. Daniel in 1893, "In sexual perversion, the woman can practice sexual abominations . . . and transmit her defects to posterity." Dr. Daniel noted that in 1893 eugenic castration of women was "being made on a large scale in a Pennsylvania hospital by Dr. Joseph Price and others."[20]

Yet against this scientific attack on manly women, a lighthearted counter voice emerged in the *National Police Gazette,* a sporting journal for men. The *Gazette* reached its heyday in 1877 under the editor Richard Kyle Fox, a former journalist, who claimed that the journal had "1,000,000 Readers Every Week!" The *Gazette* was read in barbershops all over the country, reaching many middle- and working-class men. Writing about crime and sex from police records, the *Gazette* cast a racy eye on the prowess of Victorian women. The *Gazette* found that manly women, even women dressed as men, were not abnormal or perverse. Rather a sly wink introduced the story of "She Was One of the Boys" (fig. 70) or of Annie Klein, the "'toughest girl in Newark, N.J. arrested in male attire while blowing in money she is alleged to have stolen."[21]

In fact, the *Gazette* applauded women in any attire who acted with such bravado. One reads of a Mrs. George Forester who "wallops" a man "just for fun," or of women shooting, murdering, cowhiding, beating, spanking, stabbing, tackling, horsewhipping, lashing, thrashing, and holding up men. To the merriment of the reader, women tied up an "objectionable foreman" at the Housatonic Brass Company in Birmingham, Connecticut, "because they couldn't flirt."[22]

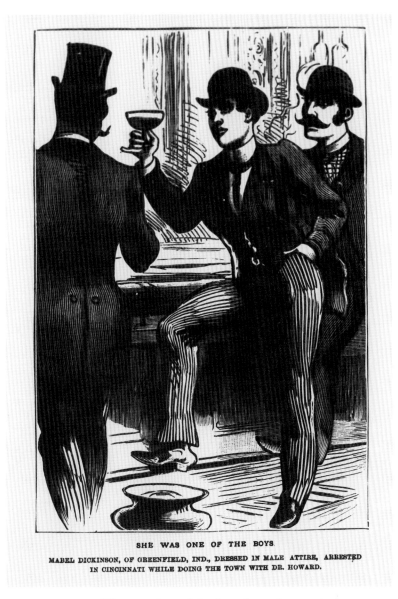

SHE WAS ONE OF THE BOYS.

MABEL DICKINSON, OF GREENFIELD, IND., DRESSED IN MALE ATTIRE, ARRESTED
IN CINCINNATI WHILE DOING THE TOWN WITH DR. HOWARD.

Fɪɢ. 70. "She Was One of the Boys," wood engraving,
National Police Gazette, October 22, 1892. Library of Congress.

Women fighters were treated with humor and awe. The *Gazette* favored
"Amazon Sluggers" or "two gay and festive New York girls" who "don skin-tight
gloves and hammer each other." Gaity Girls who quarrel or society women
fighting at a fancy ball (fig. 71) found as much applause as did "Girls in a Free
Fight" at a Brooklyn jute factory. With slick journalist jargon, the *Gazette* re-
ported on more sinister forays of women fighting each other with knives,

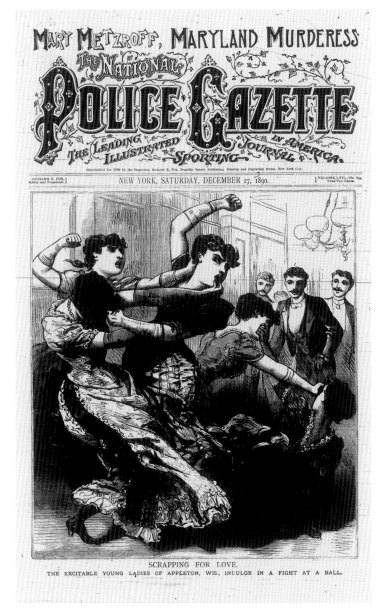

Fig. 71. "Women Fight at a Ball," wood engraving,
National Police Gazette, December 27, 1890. Library of Congress.

whips, and straps, or strangling and hanging rivals—with nary a reproach for such manly behavior.[23]

Perhaps this appreciation of female prowess reflected the commercial success of professional female boxers. In 1893, Flossie La Blanche surfaced with her "feats of strength," as well as a M'lle Athleta, a British "Champion Strong

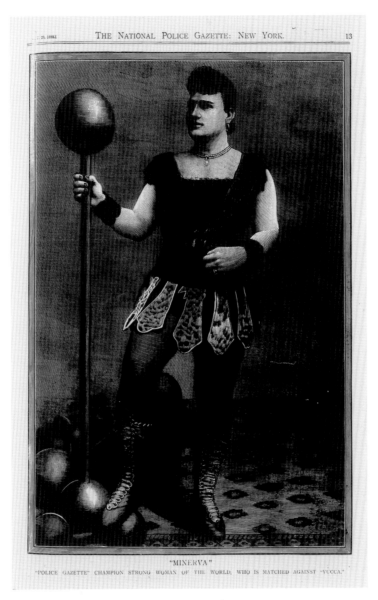

"MINERVA"
"POLICE GAZETTE" CHAMPION STRONG WOMAN OF THE WORLD, WHO IS MATCHED AGAINST "YUCCA."

FIG. 72. "Minerva: 'Police Gazette' Champion Strong Woman
of the World, Who Is Matched against 'Yucca,'"
wood engraving, *National Police Gazette*, October 28, 1893.
Library of Congress.

Woman," eager to spar with the American champion, Minerva (fig. 72). The
Gazette explained that by the 1890s women had now "become proficient with
the oar, the boxing glove, as well as shoot, run, wrestle and walk." Rowing was
the first sport taken up by the manly woman: next came walking feats (Miss
Annie Gibbons, for instance, walked 190 miles in twenty-four hours). The famous

boxer Libby Kelly appeared at Harry Hill's saloon in Brooklyn in 1878 and, noted the *Gazette,* "boxing by females then became common." Final accolades went to "a burly female," Hattie Stewart: "Not only did the giantess knock out female rivals, but held her own with professional male boxers." Female boxers were so well known that, in 1902, Thomas A. Edison produced one of his first motion pictures featuring the "Gordon Sisters Boxing."[24]

If some reports from the *Gazette* may have been farfetched, these underground happenings reflected an acceptance of the manly woman that surfaced in the culture at large. Many Victorians applauded the success of women who blazed new trails. Their masculine feats came, in time, to serve as models for social and economic mobility. Bicycling over mountain passes now became the provenance of the newly independent woman journalist. In 1898, Elizabeth Robins Pennell told an extraordinary story, "Over the Alps on a Bicycle," published in the *Century Magazine.* In all, Pennell traversed ten mountain passes, six in less than a week. "Scorched by the sun, stifled by the dust, drenched by the rain" (not to mention being exposed to snow and ice), this plucky Victorian encountered other American women on bikes too. Able both to publish her story and to praise her ordeal, Pennell announced at the journey's end: "We could, and we did."[25]

Many middle-class American women were caught up in this bicycle "craze" (fig. 73). By 1896, the *New York World* reported that "21,600 bicyclists left New York for the country on Sunday." Many were women ("women in the party can make fifty miles a day and find it play," reported *Scribner's Magazine* in 1895). Promoters were quick to seize on new markets: a kit of tools ("in solid silver") and a "bicycle rifle . . . makes the wheelwoman the most dangerous animal on a lonely road. She pulls the trigger on the slightest provocation."[26]

Promotions spread to fashions. It was chic to copy the "French Bicycle Hat" and wear wheels on your head ("the little bicycle is neatly balanced," noted the article). Many advertisements for cycling attire featured women on bicycles. And the once lamented bloomer costume was now "the only attire for women riders." Noticed, too, were "armies of women clerks . . . who go by wheel to business."[27]

This manly woman, so active and athletic, surfaced among the literati as well. Mark Twain, for one, had always paid attention to the strong woman and

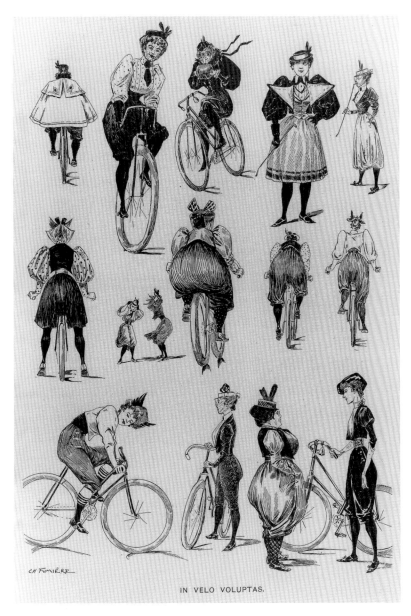

IN VELO VOLUPTAS.

Fig. 73. C. H. Fumiere, "In Velo Voluptas," *Life*, January 17, 1895.
Rutgers, The State University of New Jersey Library, New Brunswick.

the transvestite, to the bending of gender roles. Interest in the cross-dressed Joan of Arc, so visible in the 1890s, resulted in Twain's celebratory *Personal Recollections of Joan of Arc . . . as Told by Mark Twain* (1895). Twain wove a curious tale of the French King Charles, a long-haired fop dressed in brilliant colors looking like a "forked carrot" in his fitted clothes, surrounded by "his tinselled snobs and dandies." In contrast, Joan appeared astride a "great black war-steed" garbed in

steel armor, silverplated and ornamented, "polished like a mirror." Like a man, Joan was always, in Twain's eyes, "master of herself and of the situation."[28]

If Twain publicly praised the historic woman warrior, other writers addressed contemporary women. Mrs. E.D.E.N. Southworth, who published forty novels throughout her forty-four-year career, explored cross-dressing in her fiction. One story of the Civil War, *How He Won Her* (1869), celebrated the exploits of a woman disguised as a soldier who fought beside her lover, suggesting that the female soldier might have been more of a norm than we suspect. Southworth's most popular novel, *The Hidden Hand* (1888), featured a homeless girl masquerading as a boy so she could find jobs the way an "honest lad" could. Thus Southworth explored new gender roles while preserving conventional Victorian formulas (following a lover or earning an honest living), a brilliant tactic that assured wide readership while undermining Victorian stereotypes.[29]

Other women writers chose to explore more forbidden territory, the dynamics of women with women. "I loved a woman too well to love or to marry," announced one female character in a story in *Harper's New Monthly Magazine* as early as 1858. Another writer, Constance Fenimore Woolson, elicited praise from Henry James, who compared her to George Eliot, Ivan Turgenev, and Alphonse Daudet. James and Woolson, were close friends, both expatriates and writers who flirted with gender ambiguities in their work. In one short story, "Filipa," Woolson explored the love of an indigent beach girl ("dressed in a boy's suit") for a leisured aristocrat on vacation. The tenuous storyline and the unexplained relationships make the reader consider erotic possibilities the author does not directly address. In another story, "Miss Grief" (1880), a revisionist critic argues that Woolson blamed her heroine's "fatal" literary flaw (and sad life) on a lesbian sensibility. Woolson addressed issues that were known, but hidden, in Victorian America. She deliberately veiled her explorations of manly/lesbian women but her works were, nonetheless, forerunners to the modernist novel.[30]

These murmurings may have been unnoticed by most American readers. But, in the 1890s, there emerged an array of bold, independent women, mainly artists, who began to question conventional gender roles in their own lives. Such experimentation flourished in the private world of the family or in the artist's

studio. Often their activities and defiant postures edged these innovative women into the public realm as well. Thus the complex story of the manly New Woman transgressed gender stereotypes in both the public and private spheres.

Frances Benjamin Johnston, photographer and journalist, captured the vibrant experimentation of these new manly women. An avant-garde network of artistic women existed in America in the last decades of the nineteenth century. The aesthetic movement, a countercultural movement of the 1870s and 1880s, gave visibility to these artistic women in the decorative and fine arts. Johnston was part of this wave. But she moved beyond conventions by producing a self-portrait in 1896 that deliberately defied Victorian models. Her skirt is hoisted to her knee; she holds a beer stein and smokes a cigarette (fig. 74). Johnston's explorations went further, for she also made a series of herself masquerading as a man (fig. 75). In private, Johnston was breaking the boundaries between the male and female persona, suggesting that gender could be constructed. In her professional career, she also displayed a masculine verve and energy (and nonconformity) that mirrored her private philosophy.[31]

Johnston grew up in Washington, DC, with, as she explained, "the very best of the social, literary and artistic life of the National Capital." She spent two years at a boarding school and studied art in Paris from 1883 to 1885. Announcing that she would not "marry for money," Johnston received a camera and opened a studio behind her father's house. Soon the fledgling photojournalist used her connections to gain access to the White House and to photograph the celebrities of the day. Her studios in Washington, and later in New York, became centers of an artistic bohemian crowd. In 1898, for instance, a lovely Miss Berry asked to be photographed in the nude. The angry father of the girl threatened to sue Johnston when images circulated among friends and were mailed to an art magazine. Equally outrageous were photographs of two male artists by Johnston, one in drag or blackface and one "in the altogether."[32]

These high jinks exemplified the spirit and fun of the manly woman, now unrepressed in American society. Johnston never married, but had a close friendship for eight years in New York with a fellow photographer, Mattie Edwards Hewitt. In 1899, Johnston asked Theodore Roosevelt for permission to

Fig. 74. Frances Benjamin Johnston, *Self-Portrait*, ca. 1896, photograph.
Library of Congress.

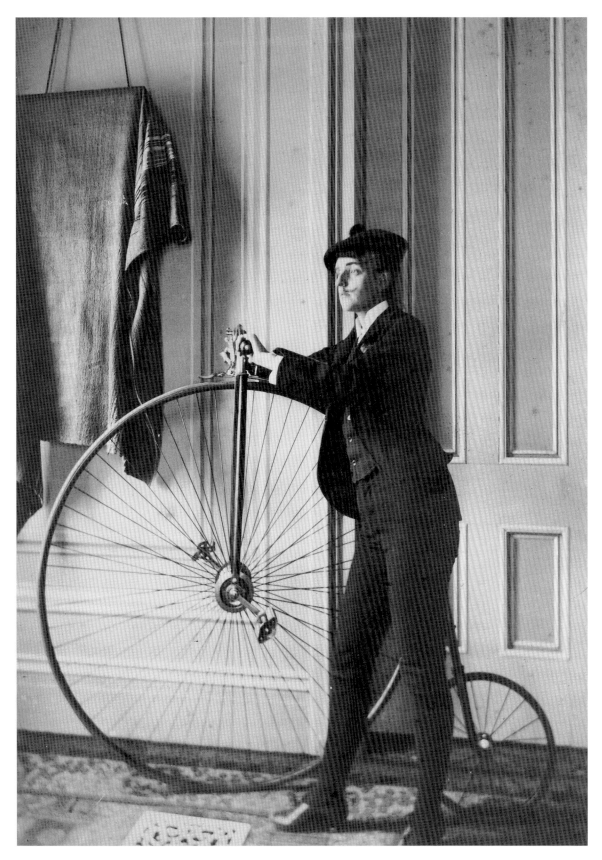

Fig. 75. Frances Benjamin Johnston, *Self-Portrait Dressed as a Man*, ca. 1880–1900, photograph. Library of Congress.

photograph the sailors on Admiral George Dewey's battleship, the USS *Olympia*. She also photographed Hampton Institute in Virginia, which appeared as "The Negro Exhibit" at the Paris 1900 Exposition. In 1901, Johnston photographed the Carlisle Indian School in Pennsylvania and, in 1902, Tuskegee Institute in Alabama. These extraordinary experiences required living aboard a navy battleship (considered a fellow drinker and "good sport") and being harassed by militant whites in Alabama ("the pluckiest woman I ever saw," noted her companion George Washington Carver), no small feats for a woman at that time.[33]

Another of these bold artists was Alice Austen. Deserted by her husband, Alice's mother moved in with her parents to their family home, Clear Comfort, overlooking the Narrows on Staten Island. Here Austen lived until she was seventy-nine years old. Growing up in a conservative upper-class society, she was nonetheless an athlete and freethinker. Not only did she win prizes in lawn tennis; she played golf, skated, exercised on high ropes and parallel bar, bicycled, used a jigsaw, and was a skilled bookbinder. Austen even illustrated an 1896 manual, *Bicycling for Women*. As an older woman, she carried a wrench, pliers, hammer, and screwdriver to repair her bicycle or her touring car.[34]

But Austen's special love was photography. By the time she was eighteen, she was an excellent photographer with an exceptional eye. Her photographs of the Victorian world around her—her family and friends, the Staten Island scene—were complicated to read. Austen slyly and with great wit parodied social tableaux. She often included herself in the portraits, a suggestion that her works were modernist performances for the camera. The hyper-realistic quality (and the comic melodrama) in her images gave many portraits an absurdist touch. It was her experiments with gender roles, however, that marked the genius of Austen's eye.

Austen included herself as actor in one daring image of three women dressed in men's clothes taken in 1891 (fig. 76). Here, a sense of drollness and mockery undermined the Victorian male stereotype, as the three figures ape manly attitudes and sprout faux mustaches. More imaginative (and raunchier) was a small detail: an umbrella, a phallic symbol, held between the legs of the

FIG. 76. Alice Austen, *Julia Martin, Julia Bredt, and Self Dressed Up as Men, 4:40 pm, Thursday, October 15th, 1891*, photograph. Staten Island Historical Association.

seated poseur. Such bold attacks on Victorian sexual norms appeared in other artificial social sets. In another photograph, the scene is a tea party. But, beneath the tea table and out of view of the actors are two men draped over one another, suggesting sexual intimacy (fig. 77). Is Austen, like Woolson, exploring the realm of a same-sex subculture existing under the eye of late nineteenth-century society?[35]

Perhaps Austen's teasing experiments in art reflected her own defiant sexual stance. One surprising photograph of Alice and a friend, Trude Eccleston, taken in 1891, showed two masked girls in petticoats, in identical mirror poses, smok-

FIG. 77. Alice Austen, *Julia Bredt and Self, Messrs. Rawl, Ordway, Blunt, Wildrick, Gibson, and Maurice, Bethlehem, Pennsylvania, Sat., Feb. 20, 1892,* photograph. Staten Island Historical Association.

ing cigarettes (fig. 78). Such provocative portraits may have suggested a mischievous connection to the underclass prostitute. Or, more subtle, Austen here used a known lesbian icon (the mirrored image) that appeared in turn-of-the-century European paintings. These were deliberate gestures, because other Austen photographs showed women wearing similar dresses in identical poses. She often photographed women with women, even in bed.[36]

As Austen dared to examine a lesbian sensibility in her art, she dared to live a nonconforming life as well. Photographs of women astride fences drinking beer or posing with lifted skirts reflected her attitude toward social and gender norms. And

Fig. 78. Alice Austen, *Trude and I Masked, Short Skirts, 11 pm, August 6th, 1891*, photograph.
Staten Island Historical Association.

in her decision to spend fifty years with a devoted friend, Gertrude Tate, Austen too existed outside social norms. The two women traveled together and eventually settled into Clear Comfort as a couple. An old family friend asserted, "Gertrude and Alice were lesbians. Gertrude was the female and Alice the male."[37]

Her legacy as a photographer was not a public one. Her work was personal, moving from the portraits of the 1890s to more panoramic pastoral themes. She also made a series of the Quarantine Station on Staten Island and carried her camera to New York, taking pictures of immigrants and documenting special events. She died at eighty-six, a year after her private photographs were finally

shown in public at the Staten Island Historical Society. Gertrude Tate, her life-long friend, expressed what many felt: "She was a rare soul, and her going leaves me bereft indeed."[38]

❧

The passing of this nineteenth-century manly New Woman, a modern Madame Nowadays, into a new century concludes the story. The barbarian persona who emerged as the New Woman became, in another evolution, the triumphant manly New Woman. In the end, women writers like Southworth and Woolson and artists like Johnston and Austen were the harbingers of new thought, new identities, and new gender roles that are now accepted in a modern world.

NOTES

PREFACE

1. Charlotte Perkins Gilman, "Is Feminism Really So Dreadful?" *Delineator*, 85 (Aug. 1914), 6. Quoted in Ellen Wiley Todd, *The "New Woman" Revised: Painting and Gender Politics on Fourteenth Street* (Berkeley: University of California Press, 1993), 1.

NOT AT HOME: THE NINETEENTH-CENTURY NEW WOMAN

I am deeply indebted to Sarah Burns, Mary Kate O'Hare, and Leslie Mitchner for their critical reading of this essay.

1. New women in nineteenth-century American art is a topic that has never been thoroughly explored. However, a number of recent art exhibitions, catalogues, and books have referenced new women and their centrality to social and gender concerns of the late nineteenth century. These publications include Erica E. Hirshler, *A Studio of Her Own: Women Artists in Boston, 1870–1940* (Boston: Museum of Fine Arts, 2001); Judith A. Barter, Erica E. Hirshler, George T. M. Shackelford, Kevin Sharp, Harriet K. Stratis, and Andrew J. Walker, *Mary Cassatt: Modern Woman* (Chicago: Art Institute of Chicago, 1998); Joyce K. Schiller, *Woman's World, 1880–1920: From Object to Subject* (Winston-Salem: Reynolda House, Museum of Art, 2000); and Martha Banta, *Imaging American Women* (New York: Columbia University Press, 1987). Scholars in other disciplines such as history,

literature, and popular culture have provided the most comprehensive analysis of nineteenth-century new women. Among the relevant studies are: Carroll Smith-Rosenberg, *Disorderly Conduct: Visions of Gender in Victorian America* (New York: Alfred A. Knopf, 1985); Ann Ardis, *New Women, New Novels: Feminism and Early Modernism* (New Brunswick, NJ: Rutgers University Press, 1990); Patricia Marks, *Bicycles, Bangs, and Bloomers: The New Woman in the Popular Press* (Lexington: University Press of Kentucky, 1990); and Lois Banner, *American Beauty* (New York: Alfred A. Knopf, 1983). Throughout the nineteenth century, new women imagery was created primarily in the Northeast despite the fact that women in the West had greater freedom and opportunities. Although not one image of a nineteenth-century new woman appears in Susan R. Ressler's *Women Artists of the American West* (Jefferson, NC: McFarland, 2003), there are numerous photographs of Western women wearing trousers; see Catherine Smith and Cynthia Greig, *Women in Pants: Manly Maidens, Cowgirls, and Other Renegades* (New York: Harry N. Abrams, 2003).

2. Lois W. Banner, *Women in Modern America: A Brief History* (New York: Harcourt Brace Jovanovich, 1974), 1–44.

3. Gail Bederman, *Manliness and Civilization: A Cultural History of Gender and Race in the United States, 1880–1917* (Chicago: University of Chicago Press, 1995), 196–206 and Carolyn Kitch, *The Girl on the Magazine Cover: The Origins of Visual Stereotyping in American Mass Media* (Chapel Hill: University of North Carolina Press, 2001), 7–11.

4. Henry James, *What Maisie Knew* (1897; rpt. London: Penguin Books, 1985), 73.

5. Rosalind Rosenberg, *Beyond Separate Spheres: Intellectual Roots of Modern Feminism* (New Haven: Yale University Press, 1982), 1–27; Tom Lutz, *American Nervousness, 1903: An Anecdotal History* (Ithaca, NY: Cornell University Press, 1991), 221–243; and S. Weir Mitchell, *Doctor and Patient* (Philadelphia: J. B. Lippincott, 1888), 84, 149, 150.

6. Mitchell, *Doctor and Patient*, 128, 130.

7. Smith-Rosenberg, *Disorderly Conduct*, 265–280. See also Mary Blanchard's essay in this volume.

8. In this essay, the phrase "New Woman" will refer specifically to emancipated

women of the 1890s, when the term was universally known and accepted. On Grand's use of it, see Marks, *Bicycles, Bangs, and Bloomers*, 10.

9. Banner, *American Beauty*, 86.

10. On the Gibson Girl, see Kitch, *The Girl on the Magazine Cover*, 37–55; Banner, *American Beauty*, 154–174; and Elizabeth Johns, ed., *Seeing Women: Students Select from the Susan and Herbert Adler Collection of American Drawings and Watercolors* (Philadelphia: Arthur Ross Gallery of the University of Pennsylvania, 1991), 35.

11. Henry James, *Daisy Miller* (1878; rpt. New York: Harper & Bros., 1879), 83.

12. For illustrations of new women types at the turn of the century, see Banta, *Imaging American Women*.

13. Gail Cunningham, *The New Woman and the Victorian Novel* (London: Macmillan, 1978), 106. Cunningham discusses the mental and physical breakdowns of new women in English novels, but an even worse fate befalls American heroines.

14. Thorstein Veblen, *The Theory of the Leisure Class* (1899; rpt. New York: Modern Library, 1934), 179.

15. For the identities of the sitters, see Natalie Spassky, Linda Bantel, Doreen Bolger Burke, Meg Perlman, and Amy L. Walsh, *American Painting in the Metropolitan Museum of Art,* vol. 2 (New York: Metropolitan Museum of Art in association with Princeton University Press, 1985), 223; for an analysis of the interior, see Teresa A. Carbone and Patricia Hills, *Eastman Johnson Painting America* (New York: Brooklyn Museum of Art in association with Rizzoli International Publications, 1999), 176, 177.

16. *Harper's Weekly* (August 1865): 534. For the most comprehensive discussion of Homer's prints dealing with new women types, see Marilyn S. Kushner, Barbara Dayer Gallati, and Linda S. Ferber, *Winslow Homer Illustrating America* (New York: Brooklyn Museum of Art in association with George Braziller, 2000).

17. For a discussion of images of misbehaving children, see Jadviga M. Da Costa Nunes, "The Naughty Child in Nineteenth-Century American Art," *Journal of American Studies* 21:2 (August 1987): 225–247.

18. For the most thorough discussions of this painting, see Jochen Wierich, "*War Spirit at Home*: Lilly Martin Spencer, Domestic Painting, and Artistic Hierarchy," *Winterthur Portfolio* 37:1 (Spring 2002): 23–42; Elizabeth L. O'Leary, *At Beck and*

Call: Representations of Domestic Servants in Nineteenth-Century American Painting (Washington, DC: Smithsonian Institution Press, 1996), 105–107; and David Lubin, *Picturing a Nation: Art and Social Change in Nineteenth-Century America* (New Haven: Yale University Press, 1994), 195–198. Sarah Burns kindly brought Wierich's article to my attention.

19. See Mary P. Ryan, *Women in Public: Between Banners and Ballots, 1825–1880* (Baltimore: Johns Hopkins University Press, 1990), 173, 174; and John Kasson, *Rudeness and Civility: Manners in Nineteenth-Century Urban America* (New York: Hill and Wang, 1990), 117.

20. Henry James, *The Bostonians* (1886; rpt. London: Penguin Books, 2000), 11.

21. Ryan, *Women in Public,* 71; and Maureen E. Montgomery, *Displaying Women: Spectacles of Leisure in Edith Wharton's New York* (New York and London: Routledge, 1998), 115. I am indebted to Barbara Dayer Gallati for bringing this book to my attention.

22. George M. Beard, *American Nervousness: Its Causes and Consequences* (1881; rpt. New York: Arno Press and the New York Times, 1972), 310. Beard felt that physical exercise was unhealthy for both sexes, but that it was more dangerous for women because of their limited supply of energy.

23. Achille Segard, *Mary Cassatt: Un Peintre des enfants et des mères* (Paris: Librairie Paul Ollendorf, 1913), quoted in Nancy Mowell Mathews, ed., *Cassatt: A Retrospective* (Westport, CT: Hugh Lauter Levin Associates, 1996), 100. Perhaps Cassatt's most famous image of the new woman type is found in her *In the Loge (At the Français, a Sketch)* (Museum of Fine Art, Boston) where the woman has adopted the male gaze. See Griselda Pollock, *Vision and Difference: Femininity, Feminism, and Histories of Art* (London and New York: Routledge, 1994), 75–79.

24. Barbara Dayer Gallati, *William Merritt Chase: Modern American Landscapes, 1886–1890* (New York: Brooklyn Museum of Art, 1999), 143.

25. I am indebted to Erica Hirshler for this observation regarding the woman's reading material. See also James, *What Maisie Knew,* 253, where Mrs. Beale reads a French novel with a yellow cover.

26. Banner, *American Beauty,* 146.

27. Harry Campbell, *Differences in the Nervous Organization of Man and Woman* (London: Lewis, 1891), 173; quoted in Bederman, *Manliness and Civilization,* 107.

28. Edward H. Clarke, *Sex in Education; or, A Fair Chance for the Girls* (1873; rpt. New York: Arno Press and the New York Times, 1972), 68.

29. For an insightful survey of women reading in eighteenth- and nineteenth-century American art, see Linda J. Docherty, "Woman as Readers: Visual Interpretations," *Proceedings of the American Antiquarian Society* 107:2 (1998): 335–388. I am grateful to Mary Kate O'Hare for bringing this article to my attention.

30. In 1878 and 1879 Cassatt was preoccupied with the theme of women reading newspapers, painting two other works besides this one of her mother: *Woman Reading (Portrait of Lydia Cassatt, the Artist's Sister),* 1878–79 (Joslyn Art Museum, Omaha, Nebraska) and *On a Balcony,* 1878–79 (The Art Institute of Chicago). In both works Cassatt's sister Lydia is the model.

31. Norma Broude, "Mary Cassatt: Modern Woman or the Cult of True Womanhood?" *Woman's Art Journal* 21:2 (Fall/Winter 2001): 37.

32. For a discussion of the contemporary critical response to this work, see Margaret C. Conrads, *Winslow Homer and the Critics: Forging a National Art in the 1870s* (Princeton, NJ: Princeton University Press in association with the Nelson-Atkins Museum of Art, 2001), 125–128, 141, 162, 174–176.

33. Julie Wosk, *Woman and the Machine: Representations from the Spinning Wheel to the Electronic Age* (Baltimore: Johns Hopkins University Press, 2001), 23.

34. Homer was the first to paint professional women when in the 1870s he began a series of schoolteachers in their classrooms. See Sarah Burns's essay in this volume. For a survey of nineteenth-century women in commerce, see Virginia G. Drachman, *Enterprising Women: 250 Years of American Business* (Chapel Hill: University of North Carolina Press, 2002).

35. Kirsten Swinth, *Painting Professionals: Women Artists and the Development of Modern Art, 1870–1930* (Chapel Hill: University of North Carolina Press, 2002), 3, 5.

36. David B. Dearinger, "Women Artists at the National Academy of Design: The First Hundred Years," in *Challenging Tradition: Women of the Academy, 1826–2003* (New York: National Academy of Design, 2003), 16.

37. For more information on this painting, see Gail Levin, Alessandra Comini, and

Wanda M. Corn, *American Women Artists, 1830–1930* (Washington, DC: National Museum of Women in the Arts, 1987), cat. no. 43. See also Lois Marie Fink, "American Renaissance: 1870–1917," in Fink and Joshua C. Taylor, *Academy: The Academic Tradition in American Art* (Washington, DC: Smithsonian Institution Press, 1995), 61, 62, for a brief discussion of the female life class. Stephens also painted *The Woman in Business,* 1897 (Brandywine River Museum) that shows women as both workers and shopper in Wanamaker's department store in Philadelphia. This painting addresses women in the workforce.

38. William Dean Howells, *A Hazard of New Fortunes* (1890; rpt. New York: Meridian, 1994), 182.

39. For information on Nourse see Mary Alice Heekin Burke, *Elizabeth Nourse, 1859–1938: A Salon Career* (Washington, DC: Smithsonian Institution Press, 1983). Like Cassatt, Nourse was well known for her paintings of mothers and children, subjects viewed as particularly appropriate for female artists, who were thought to have an intuitive understanding of them.

40. Margaret Moore Booker thinks this painting is probably a self-portrait of Coffin. See her *Nantucket Spirit: The Art and Life of Elizabeth Rebecca Coffin* (Nantucket, MA: Mill Hill Press, 2001), 81, 82.

41. For information on this painting, see Kenneth T. Jackson, *Perspectives on the Collections of The New-York Historical Society* (New York: The New-York Historical Society, 2000), 47; and Levin, Comini, and Corn, *American Women Artists, 1830–1930,* cat. no. 39.

42. Hale, who was editor of *Godey's* from 1837 to 1877, was one of the few female writers to work outside the home. Initially she had to support her large family, but by the time she retired at the age of ninety, she was no longer financially responsible for them.

43. Veblen, *The Theory of the Leisure Class,* 354.

44. Bederman, *Manliness and Civilization,* 28.

45. For a fascinating survey of female cross-dressing, see Smith and Greig, *Women in Pants.*

46. See Blanchard's essay in this volume.

47. For an informative analysis of Homer's croquet scenes, see David Park Curry,

Winslow Homer: The Croquet Game (New Haven: Yale University Art Gallery, 1984).

48. Alice Austin was one of the first photographers to record women playing tennis. For more information on Austin see Ann Novotny, *Alice's World: The Life and Photography of an American Original: Alice Austin, 1866–1952* (Old Greenwich, CT: Chatham Press, 1976).

49. For reproductions of two of Vonnoh's preliminary sketches, see May Brawley Hill, *Grez Days: Robert Vonnoh in France* (New York: Berry-Hill Galleries, 1987), 33, 34.

50. Wosk, *Woman and the Machine,* 97.

51. "The World Awheel," *Munsey's* (May 1896): 131; quoted in ibid., 97.

52. In her book on bicycling that included illustrations based on photographs of Alice Austin, Maria E. Ward recommends stopping for water on excursions. See her *Bicycling for Ladies* (New York: Brentano's, 1896), 107.

53. The flowers may have been provided by the sculptor William R. O'Donovan, who was smitten by Cook. See John Wilmerding, *Thomas Eakins* (Washington, DC: Smithsonian Institution Press, 1993), 117, 118. For a discussion of *The Concert Singer* in the context of Eakins's lifelong interest in music, see Elizabeth Johns, *Thomas Eakins: The Heroism of Modern Life* (Princeton, NJ: Princeton University Press, 1983), 115–143.

54. Barbara Gallati believes that this portrait probably depicts Spong as she appeared in her role as Lady Algernon Cheltand in the comedy *Lord and Lady Algy* that opened in New York in December of 1903. See her *William Merritt Chase* (New York: Harry N. Abrams, 1995), 107.

55. See Blanchard's essay on the success of Lotta Crabtree.

56. According to Bruce Weber, Wheeler was Chase's first female student, and she worked with him in his Tenth Street Studio from 1879 to 1881. Although William Morris Hunt had instructed women in Boston as early as the 1860s, Chase was one of the first to accept women pupils. See Weber and Sarah Kate Gillespie, *Chase Inside and Out: The Aesthetic Interiors of William Merritt Chase* (New York: Berry-Hill Galleries, 2004), 32–34.

57. Both quotes are from Karal Ann Marling, "Portrait of the Artist as a Young

Woman: Miss Dora Wheeler," *Bulletin of the Cleveland Museum of Art* 65:2 (February 1978), 47, 48.

58. See Richard Ormond and Elaine Kilmurray, *John Singer Sargent: Portraits of the 1890s* (New Haven: Yale University Press, 2002), 122, for Stokes's description of the commission in her unpublished "Random Recollections of a Happy Life" (1923).

59. For this interpretation, see Ellen Wiley Todd, *The "New Woman" Revised: Painting and Gender Politics on Fourteenth Street* (Berkeley: University of California Press, 1993),10, 11.

60. See Ormond and Kilmurray, *John Singer Sargent,* 164, 165.

61. For a comprehensive study of early twentieth-century new women, see Todd, *The "New Woman" Revised.*

WINSLOW HOMER'S AMBIGUOUSLY NEW WOMEN

1. On feminism and related topics see Mary Ryan, *Women in Public: Between Banners and Ballots, 1825–1880* (Baltimore: Johns Hopkins University Press, 1990); William Leach, *True Love and Perfect Union: The Feminist Reform of Sex and Society* (New York: Basic Books, 1980), and Carroll Smith-Rosenberg, *Disorderly Conduct: Visions of Gender in Victorian America* (New York: Alfred A. Knopf, 1985). The suffrage movement split over the Fifteenth Amendment, which extended the franchise only to black males; the New York contingent urged defeat of the amendment while the Boston faction supported its passage.

2. Elizabeth Johns, *Winslow Homer: The Nature of Observation* (Berkeley: University of California Press, 2002), 60–66, argues that during this period the courtship theme in Homer's art reflects his desire for courtship in life. Nicolai Cikovsky, Jr., "Modern and National," in Cikovsky and Franklin Kelly, *Winslow Homer*, exhibition catalogue (New Haven: Yale University Press for National Gallery of Art, 1995), 62–63, defines Homer's women in the post–Civil War period as distinctly and inherently modern. Other scholars contend that his images of women are more ambiguous: see Karen A. Sherry, "Women on the Edge: Liminal Female Identities in Winslow Homer's Representations of Long Branch, New Jersey"

(M.A. thesis, University of Delaware, 2001), who argues in essence that Homer's representations of Long Branch are "fraught with tensions about the identity and role of the newly independent, modern women in the post-war period" (3).

3. Homer painted *The Bridle Path* in 1868. The original title, under which he exhibited the work in 1870, was *The White Mountains*; the title *Bridle Path, White Mountains* dates from 1951, when the work entered the Clark collection. I thank Colleen Terry of the Clark Art Institute for this information. Since the modern title is the more familiar, I use it here. See David Tatham, "From Paris to the Presidentials: Winslow Homer's *Bridle Path, White Mountains*," *American Art Journal* 30:1, 2 (1999): 36–49, for an excellent analysis of the painting in its artistic and historical contexts. Tatham views Homer's rider as "an early example in American painting of the New Woman" (43). See Carroll Smith-Rosenberg, "The New Woman as Androgyne," in Smith-Rosenberg, *Disorderly Conduct*, 245–296, for a useful overview and analysis of the New Woman's emergence and evolution in the late nineteenth century. As Smith-Rosenberg points out, the first generation of New Women was associated in particular with the new women's colleges established (for the most part) after the Civil War.

4. Eugene Benson, "The Annual Exhibition of the Academy," *Putnam's Magazine* 5 (June 1870): 702–703.

5. This style of hat is identified as a "gypsy" in *Harper's Bazar* 4 (May 28, 1871): 322.

6. See Bryan J. Wolf, "The Labor of Seeing: Pragmatism, Ideology, and Gender in Winslow Homer's *Morning Bell*," *Prospects* 17 (1992): 283, for a reading of *The Bridle Path* as a "narrative of courtship and romance."

7. "New York Fashion: Riding Habits," *Harper's Bazar* 2 (July 24, 1869): 467. See Judith Elaine Leslie, "Sports Fashions as a Reflection of the Changing Role of American Women in Society from 1850 to 1920" (Ph.D. diss., University of North Carolina at Greensboro, 1985), 50–56, 84–93, for discussion of riding and equestrienne fashion in the middle decades of the nineteenth century; and Barbara A. Schreier, "Sporting Wear," in *Men and Women: Dressing the Part*, ed. Claudia Brush Kidwell and Valerie Steele, exhibition catalogue (Washington, DC: Smithsonian Institution Press for the National Museum of American History, 1989), 106–109.

8. Another set of caricatures in *Harper's Bazar* (2 [Aug. 1869]: 557) shows the

"Girls" bathing at a public pool, fishing from a boat, rowing in crews, and playing kickball—all in full fashionable gear. The phrase "Girl of the Period" was coined by the English journalist Eliza Lynn Linton in an article published in the *Saturday Review* in 1868. Americans were quick to appropriate the image and the idea. On Linton see Christina Boufis, "'Of Home Birth and Breeding': Eliza Lynn Linton and the Girl of the Period," in *The Girl's Own: Cultural Histories of the Anglo-American Girl, 1830–1915,* ed. Claudia Nelson and Lynne Vallone (Athens: University of Georgia Press, 1994), 98–123.

9. Dio Lewis, *Our Girls* (New York: Harper & Bros., 1871), 60–62, 105. Lewis's voice stands for the many who inveighed against the cult of extreme fashion and bodily distortion. See also Eugene Benson, "About Women and Dress," *Appleton's Journal of Popular Literature, Science, and Art* 1 (April 3, 1869): 22–24; "An Article of Female Dress," *Galaxy* 2 (1866): 570–575; Stephen Fiske, "American Girls of the Period: The New Yorker," *Harper's Bazar* 2 (May 29, 1869): 343, as typical examples of the antifashion critique. Although the authors cited here are male, many female voices also joined the debate, including the feminist and dress reformer Abba Gould Woolson.

10. Porte-Plume, "More about Pictures and Painters," *The Citizen and Round Table* 6 (May 1870): 855; "National Academy of Design," *New York Evening Post,* April 27, 1870.

11. Harriet Beecher Stowe, *Little Pussy Willow* (Boston: Houghton Mifflin, 1890), 87, 111, 112. The story was first published as a serial in 1866–67 in *Our Young Folks*.

12. Louisa May Alcott, *An Old-Fashioned Girl* (Boston: Roberts Bros., 1894), 3–4, 6, 9, 37. The story first appeared as a serial in 1869 in *Merry's Museum*.

13. Charlotte Perkins, Diary, cited in Jane H. Hunter, *How Young Ladies Became Girls: The Victorian Origins of American Girlhood* (New Haven: Yale University Press, 2002), 271–274. I am indebted to Hunter's highly informative and valuable study for my profile of "real" American girls during the postwar epoch. Of course urban streets were not always neutral territory. Concurrently, social critics and moralists expressed anxiety when the "Ladies' Mile," the fashionable promenade on Broadway in New York City, became a new public sphere for the display of female autonomy and eroticism; see David Scobey, "'Nymphs and

Satyrs': Sex and the Bourgeois Public Sphere in Victorian New York," *Winterthur Portfolio* 37:1 (Spring 2002): 43–66.

14. Johns, *Winslow Homer: The Nature of Observation,* 55–56, also notes the resemblance of the well-dressed male figure in this illustration to Homer.

15. Stowe, *Little Pussy Willow,* 58, describes her heroine's white cambric dress and blue ribbon; also Pussy has a straw bonnet tied with "long strings of blue ribbon." In Alcott's *Old-Fashioned Girl,* 127, we learn of the best dress Polly has brought with her to Boston: a new white muslin dress, with fresh blue ribbons.

16. See David Park Curry, *Winslow Homer: The Croquet Game*, exhibition catalogue (New Haven: Yale University Art Gallery, 1984), for a thorough discussion of Homer's croquet scenes in their historical and social context.

17. Frances B. Cogan, *The All-American Girl: The Ideal of Real Womanhood in Mid-Nineteenth-Century America* (Athens: University of Georgia Press, 1989), 3–26, 74.

18. Eugene Benson, "The 'Woman Question,'" *Galaxy* 2 (Dec. 15 1866): 754. In the late 1860s, Benson, ironically, lived in an adulterous relationship with Henrietta Marlan Fletcher, the wife of a prominent Massachusetts clergyman and mother of two children. Eventually they married and became permanent expatriates in Italy in 1873. See Robert J. Scholnick, "Between Realism and Romanticism: The Curious Career of Eugene Benson," *American Literary Realism, 1870–1910* 14:2 (1981): 242–261.

19. "Some American Young Women," *Harper's Bazar* 4 (Jan. 21, 1871): 42–43; Wilcox, "An Article of Female Dress," 575; "Literary," *Appleton's Journal of Popular Literature, Science, and Art* 14 (Nov. 6, 1875): 601. The last cited the opinion of the English reviewer Agnes Macdonnell because *Appleton's* editor judged her assessment of the "American heroine" to be more discriminating and just "than critics on American matters in English periodicals generally are." We can assume therefore that *Appleton's* endorsed the English writer's evaluation of the fictional American girl.

20. Pamela Sachant reaches a similar conclusion while following a different line of argument in "Winslow Homer in the White Mountains, 1868–1870: Portraits of an Uncertain Land" (unpublished seminar paper, University of Delaware, n.d.). I am grateful to Dr. Sachant for sharing her fine work with me.

21. Judith Walsh, "The Language of Flowers and Other Floral Symbolism Used by Winslow Homer," *The Magazine Antiques* 156:5 (Nov. 1999): 713.

22. Nicolai Cikovsky, Jr., "Winslow Homer's *School Time*: 'A Picture Thoroughly National,'" in *Essays in Honor of Paul Mellon, Collector and Benefactor,* ed. John Wilmerding (Washington, DC: National Gallery of Art, 1986), 53–57.

23. Sandra Brandmark Fowler, "The Character of the Woman Teacher during Her Emergence as a Full-Time Professional in Nineteenth-Century America: Stereotypes vs. Personal Histories" (Ph.D. diss., Boston University, 1985), 46. I have relied on Fowler's excellent information and analysis in my discussion of the feminization of teaching. Also see John L. Rury, "Who Became Teachers? The Social Characteristics of Teachers in American History," in *American Teachers: Histories of a Profession at Work,* ed. Donald Warren (New York: Macmillan, 1989), 33–38. On Catherine Beecher's important role in promoting women teachers see Kathryn Kish Sklar, *Catherine Beecher: A Study in American Domesticity* (New Haven: Yale University Press, 1973).

24. Kathleen Weiler, "Women's History and the History of Women Teachers," *Journal of Education* 171:3 (1989): 18; Fowler, "The Character of the Woman Teacher," 37–53.

25. Fowler, "The Character of the Woman Teacher," 55–56, 70–72.

26. Nancy Hoffman, *Woman's 'True' Profession: Voices from the History of Teaching* (Old Westbury, NY: Feminist Press, 1981), xvii–xviii. Randall Griffin has also discussed the celibacy and isolation of contemporary schoolteachers with reference to Homer's imagery; see his *Homer, Eakins, and Anshutz: The Search for American Identity in the Gilded Age* (University Park: Pennsylvania State University Press, 2004), 53.

27. "The District School Teacher," *Harper's Weekly* 12 (Nov. 9, 1867): 706.

28. "Leaves from the Diary of a New England Schoolteacher," *Arthur's Home Magazine* (1854), quoted in Michelle Dawn Cude, "Schoolhouses Remembered: The Story behind the Nostalgic Image" (M.A. thesis, College of William and Mary, 1997), 29.

29. Gail Hamilton, Sept. 5, 1874, quoted in Fowler, "The Character of the Woman Teacher," 125.

30. These include *Nurse and Child,* 1866 (Century Association, New York); *The Nurse,*

1867 (Terra Museum of Art, Chicago), and "On the Beach at Long Branch—The Children's Hour," a wood engraving published in *Harper's Weekly* 18 (Aug. 15, 1874): 672.

31. On fashionable aprons see, for example, "Chitchat: On Fashions for July," *Godey's* 89 (July 1874): 102; on functional coverings see "Every-Day Dresses, Garments, Etc.," *Peterson's Magazine* 57 (April 1870): 309. Women working in textile mills also wore aprons; see Joan L. Severa, *Dressed for the Photographer: Ordinary Americans and Fashion, 1840–1900* (Kent, OH: Kent State University Press, 1995), 263, 370.

32. Cude, "Schoolhouses Remembered," 9. The modernity of the blackboard constitutes a major tenet of Cikovsky's argument; see "Winslow Homer's *School Time*," 48–59. Blackboards were introduced into the United States by mathematics teachers around 1800, and by the 1840s that they were widely used in classrooms from elementary schools to colleges. The Massachusetts educator William A. Alcott wrote that "A Blackboard in every schoolhouse is as indispensably necessary as a stove or a fireplace." See Peggy Kidwell, "Slates, Slide Rules, and Software: Teaching Math in America, The Early Republic," http://americanhistory.si.edu/teachingmath/html/101.htm.

33. David Tatham, *Winslow Homer in the Adirondacks* (Syracuse, NY: Syracuse University Press, 1996), 68. In discussing Homer's work in the Adirondacks, I am much indebted to Tatham's essential and meticulous research on that subject. I also thank Teresa A. Carbone for generously sharing the manuscript of her forthcoming catalogue entry on *In the Mountains*.

34. Another "pendant" pair from the same period is *A Visit from the Old Mistress* (1876; Smithsonian American Art Museum) and *Sunday Morning in Virginia* (1877; Cincinnati Art Museum). Both use the same setting, the interior of a cabin, inhabited by former slaves.

35. Tatham, *Winslow Homer in the Adirondacks*, 37.

36. Edwin R. Wallace, *A Descriptive Guide to the Adirondacks, Revised and Corrected,* 8th ed. (Syracuse, NY: Privately printed, 1880); H. Perry Smith, *The Modern Babes in the Wood; or, Summerings in the Wilderness* (Hartford, CT: Columbian Book Co., 1872), 6. The bibliography on the Adirondacks is large; see Dorothy A. Plum, ed., *Adirondack Bibliography: A List of Books, Pamphlets, and Periodical Articles Published*

through the *Year 1955* (Gabriels, NY: Adirondack Mountain Club, 1958). In addition to Tatham, *Winslow Homer in the Adirondacks*, I have relied on Craig Gilborn, *Adirondack Camps: Homes away from Homes, 1850–1950* (Syracuse, NY: Syracuse University Press, 2000).

37. Amelia Murray, *Letters from the United States, Cuba, and Canada*, as quoted in Paul F. Jamieson, ed., *The Adirondack Reader* (New York: Macmillan, 1964), 235–241; Sarah Goodyear, "In the Wilderness," *Forest and Stream 3* (Oct. 15, 1874): 145–146.

38. Kate Field, "In and Out of the Woods," *Atlantic Almanac* (1870): 48–52.

39. Tatham, *Winslow Homer in the Adirondacks*, 67. Tatham goes on to say that "these visitors to the wilderness almost certainly follow a marked trail," product of a movement in which women were active participants, "to give the public safe access to forests and mountains through the building of marked trails for self-guided hiking."

40. Charles Dudley Warner, *In the Wilderness* (Boston: Houghton, Osgood, 1878), 63–64.

41. Tatham, *Winslow Homer in the Adirondacks*, 66, also sees the four as New Women.

THE MANLY NEW WOMAN

1. Mrs. Roy Devereux, *The Ascent of Woman* (Boston: Roberts Brothers, 1896), 157–158. On the fascination with the "savage woman" at the turn of the century as both alluring and degenerate, see Bram Dijkstra, *Idols of Perversity: Fantasies of Feminine Evil in Fin-de-Siècle Culture* (New York: Oxford University Press, 1986), 213, 324–325.

2. Devereux, *Ascent of Woman*, 46.

3. Mrs. Burton Harrison, "A Newport Symposium," *North American Review* 163 (1896): 239.

4. Patricia Campbell Warner, "The Gym Suit: Freedom at Last," in *Dress in American Culture*, ed. Patricia A. Cunningham and Susan Voso Lab (Bowling Green, OH: Bowling Green State University Popular Press, 1993), 142–159.

5. Valerie Steele, "Appearance and Identity," in *Men and Women: Dressing the Part*,

ed. Claudia Brush Kidwell and Valerie Steele (Washington, DC: Smithsonian Institution Press, 1989), 12–14; Catherine Smith and Cynthia Greig, *Women in Pants: Manly Maidens, Cowgirls, and Other Renegades* (New York: Harry N. Abrams, 2003), 46–59, 72–83; Lillian Schlissel, *Women's Diaries of the Westward Journey* (New York: Schocken Books, 1982), 105, 141.

6. Gayle V. Fischer, *Pantaloons and Power: A Nineteenth-Century Dress Reform in the United States* (Kent, OH: Kent State University Press, 2001), 17, 37, 35. John Humphrey Noyes wrote that his reform costume would "break up effeminacy" and allow women to take "part in many kinds of industry usually considered masculine." Noyes eventually proposed a less severe pantaloon, like "the dress of children." Evidence from letters suggested that this child's dress might have reflected a deviant sexual reaction: women dressed as children became sexually exciting to Noyes and male followers. See Fischer, *Pantaloons and Power,* 57–58, 63–75.

7. Ibid., 89, 131; Patricia A. Cunningham, *Reforming Women's Fashion, 1850–1920: Politics, Health, and Art* (Kent, OH: Kent State University Press, 2003), 38–44. On the American Free Dress League, the "American costume," and water-cure and dress reform groups, see ibid., 44–57.

8. *Vivandières* also modeled their costumes after the rational or bloomer dress styles. Often patriotic outfits (one *vivandière* was married in a "Turkish costume" with "a blouse of cherry-colored satin, pants of blue and a felt hat with white plumes—the national colors"), the costume was well known in America through Donizetti's opera *La Fille du Regiment*. During the early years of the war, American prima donna Clara Louise Kellogg starred in productions that included her playing the drum and singing American patriotic anthems, featuring real Zouaves. http://www.sallyqueenassociates.com/girls61.htm.

9. Larry G. Eggleston, *Women in the Civil War: Extraordinary Stories of Soldiers, Spies, Nurses, Doctors, Crusaders, and Others* (Jefferson, NC: McFarland, 2003), 138–140; Smith and Greig, *Women in Pants,* 27; http://www.gdg.org/mtepe.html; http://www.ehistory.com/uscw/features/articles/0005/vivandieres.cfm.

10. Smith and Greig, *Women in Pants,* 61; Eggleston, *Women in the Civil War,* 2, 12–15.

11. Eggleston, *Women in the Civil War,* 16–22; http://mariah.stonemarch.org/livhis/women/cashier.htm.

12. Eggleston, *Women in the Civil War,* 179–180. Fischer, *Pantaloons and Power,* 147–153; Smith and Greig, *Women in Pants,* 31.

13. Quotations from Fischer, *Pantaloons and Power,* 150, 154.

14. Barbara Goldsmith, *Other Powers: The Age of Suffrage, Spiritualism, and the Scandalous Victoria Woodhull* (New York: Alfred A. Knopf, 1998).

15. *Cincinnati Commercial,* May 11, 1872, quoted in http://spartacus. schoolnet. co.uk/USAwoodfullV.htm; Goldsmith, *Other Powers,* 303. In "The Ethics of Sex," M. A. Hardaker notes the "free-love philosophy" as a "movement which attempts the destruction of the family." *North American Review* 131 (1880): 72.

16. Goldsmith, *Other Powers,* 402, 193–195. Quotations are from Ishbel Ross, *Charmers and Cranks: Twelve Famous American Women Who Defied Conventions* (New York: Harper & Row, 1965), 115–116 and M. M. Barberry, *Vicky: A Biography of Victoria C. Woodhull* (New York: Funk & Wagnalls, 1967), 269–270. Amanda Frisken, "Sex in Politics: Victoria Woodhull as an American Public Woman, 1870–76," *Journal of Women's History* 12:1 (Spring 2000): 89–110. On April 15, 1873, Anthony Comstock described in his diary "the most disgusting set of Freelovers. The women, thin-faced, cross, sour-looking, each wearing a look of 'Well, I am boss'." Quoted in Goldsmith, *Other Powers,* 369. Mary Gabriel, *Notorious Victoria: The Life of Victoria Woodhull, Uncensored* (Chapel Hill, NC: Algonquin Books, 1998), 247–248, 283, 285; Joanne E. Passet, *Sex Radicals and the Quest for Women's Equality* (Urbana: University of Illinois Press, 2003), 91–111.

17. David Dempsey with Raymond P. Baldwin, *The Triumphs and Trials of Lotta Crabtree* (New York: William Morrow, 1968), 162; http://www.ncgold.com/History /LottaCrabtree/lotta.html; Constance Rourke, *Troupers of the Gold Coast; or, The Rise of Lotta Crabtree* (New York: Harcourt, Brace, 1928), 86–87, 204.

18. On fin-de-siècle women seen as "vicious, bestial creatures" and "the monstrous goddess of degeneration," see Dijkstra, *Idols of Perversity,* 324–325; Linda Dowling, "The Decadent and the New Woman in the 1890s," *Nineteenth-Century Fiction* 33 (1978): 434–453. On Oscar Wilde's *Salome* as a lesbian asserting female power, see Richard Dellamora, "Traversing the Feminine in Oscar Wilde's *Salome*," in *Victorian Sages and Cultural Discourse: Renegotiating Gender and Power,* ed. Thais E. Morgan (New Brunswick, NJ: Rutgers University Press, 1990), 247. For

an overview of the period, see Elaine Showalter, *Sexual Anarchy: Gender and Culture at the Fin de Siècle* (New York: Viking, 1990).

19. On fear of the Amazon New Woman, see Talia Schaffer, *The Forgotten Female Aesthetes: Literary Culture in Late-Victorian England* (Charlottesville: University Press of Virginia, 2000), 89; Richard Dellamora, *Sexual Desire: The Sexual Politics of Victorian Aestheticism* (Chapel Hill: University of North Carolina Press, 1990), 136–142; Dijkstra, *Idols of Perversity,* 309–314; William S. Walsh, "The Conceited Sex," *North American Review* 159 (1894): 373; Alison Mackinnon, *Love and Freedom: Professional Women and the Reshaping of Personal Life* (Cambridge: Cambridge University Press, 1997), 16–47. On the perception that in the 1890s women were taking over the literary world, see Ann Ardis, *New Women, New Novels: Feminism and Early Modernism* (New Brunswick, NJ: Rutgers University Press, 1990), 43; William A. Hammond, "Woman in Politics," *North American Review* 137 (1883): 137–146; Devereux, *Ascent of Woman,* 95; Jessie DeFoliart Hamblin, *A New Woman* (Chicago: Charles H. Kerr, 1895), 117; Jane Wood, *Passion and Pathology in Victorian Fiction* (Oxford: Oxford University Press, 2001), 171. On medical knowledge as erotic (male) sexual fantasy, see Ludmilla Jordanova, *Sexual Visions: Images of Gender in Science and Medicine between the Eighteenth and Twentieth Centuries* (Madison: University of Wisconsin Press, 1989), 62–104.

20. Jonathan Katz, *Gay American History: Lesbians and Gay Men in the U.S.A.* (New York: Harper Colophon Books, 1976), 60, 61, 221–225, 134–136. Similarly, "life incarceration and castration" were recommended for the "lesbian lover." Dr. C. H. Hughes, "Erotopathia—Morbid Eroticism," in Jonathan Ned Katz, *Gay/Lesbian Almanac: A New Documentary* (New York: Harper & Row, 1983), 240, 245; Dijkstra, *Idols of Perversity,* 148–159.

21. Howard Chudacoff argues that Fox felt that there was "sexual attraction in the concept of female power," a gambit to sell the magazine. Female aggression was often working-class women against upper-class men ("swells" and "mashers"), suggesting that the *Gazette* reader, often the blue-collar worker, enjoyed the humiliation of men from higher social strata. Fox overstated the *Gazette*'s circulation that was, in the 1880s, about 150,000. Howard P. Chudacoff, *The Age of the Bachelor: Creating an American Subculture* (Princeton, NJ: Princeton University Press,

1999), 185–210. See also Mark Gabor, *The Illustrated History of Girlie Magazines: From National Police Gazette to the Present* (New York: Harmony Books, 1984), 15–25. Gene Smith and Jayne Barry Smith, eds., *The Police Gazette* (New York: Simon and Schuster, 1972. Examples are: "She Wore Men's Togs," *National Police Gazette,* February 15, 1890, 9; "She Was One of the Boys," *National Police Gazette,* October 22, 1892, 8; "She Wore Trousers," *National Police Gazette,* October 28, 1893, 1; "A Bold Girl Pirate" ("Grace Smith, who wears trousers and smokes cigarettes, steals a yacht at Riverhead"), *National Police Gazette,* September 1, 1894, 8.

22. Examples are: "She Walloped Two Men," *National Police Gazette,* November 9, 1889, 12; "Because They Couldn't Flirt," *National Police Gazette,* February 8, 1890, 12; "She Cowhided Him," *National Police Gazette,* March 29, 1890, 12; "And They Buffed Each Other," *National Police Gazette,* May 24, 1890, 16; "Frail Women Don War Paint," *National Police Gazette,* October 8, 1892, 5. This is only a small sample of the many items printed.

23. "Hanging in a Female Seminary," *National Police Gazette,* May 31, 1890, 1; "Amazon Sluggers," *National Police Gazette,* August 23, 1890, 1; "Women Fight at a Ball," *National Police Gazette,* December 27, 1890; "Girls in a Free Fight," *National Police Gazette,* March 4, 1893, 5; "Women Fight Like Men," *National Police Gazette,* June 16, 1894, 1, are some of the many articles on fighting women.

24. "Real Ladies in the Ring," *National Police Gazette,* November 2, 1889, 5; "Female Prize Fighters" ("a Morrisville, N.J., contest"), *National Police Gazette,* September 30, 1890, n.p.; "Women in the Prize Ring," *National Police Gazette,* September 24, 1892, 11; "Miss Hattie Leslie" ("Late Champion Female Boxer of the World Who Died in Milwaukee, Wis., on Sept. 24"), *National Police Gazette,* October 8, 1892, 13; "Flossie La Blanche," *National Police Gazette,* February 4, 1893, 13; "Women Don the Gloves," *National Police Gazette,* March 31, 1894, 5; "M'lle Athleta," *National Police Gazette,* June 2, 1894, 13.

25. Carolyn Kitch, *The Girl on the Magazine Cover: The Origins of Visual Stereotypes in American Mass Media* (Chapel Hill: University of North Carolina Press, 2001), 8; Jane H. Hunter, *How Young Ladies Became Girls: The Victorian Origins of American Girlhood* (New Haven: Yale University Press, 2002); Elizabeth Robins Pennell, "Over the Alps on a Bicycle," *Century Magazine* 55 (1898): 837–851.

26. "Is Bicycle Riding on Sunday Wicked?" *New York World,* May 16, 1896, 3; Philip G. Hubert, Jr., "The Bicycle," *Scribner's Magazine* 12 (January-June 1895): 693; "Novelties for the Cyclist," *New York World,* June 8, 1896, 4; "New Bicycle Catamaran," *New York World,* June 8, 1896, 4; "Bicycles to Skim the Ice," *New York Herald,* March 11, 1896, 3; "A Sixty-Pound Electric Bike," *New York World,* April 22, 1896; "Hints on Bike Racing," *New York World,* March 25, 1896; "The Railroad Wheel," *New York World,* January 27, 1896, 4. See also J. West Roosevelt, "A Doctor's View of Bicycling" ("cycling is both beneficial and safe for any woman who is free from organic disease"), *Scribner's Magazine* 17 (1895): 712; "The Wheel of Today," *Scribner's Magazine* 17 (1895): 696–702.

27. "Wear Wheels on Their Hats," *New York World,* May 18, 1896, 3; "Zimmerman Tells How to Ride Fast," *New York World,* March 18, 1896, 3; "Woman's Latest Whims and Fashions," *New York World,* April 6, 1896, 3; "Latest Bicycle Stocking," *New York World,* April 20, 1896, 4. Ads: *New York World,* April 29, 1896, 3; April 29, 1896, 6; "Merritt's Cycling Suit," *Ladies' Home Journal* (May 1896): 24; "Bicycle Waist," *Ladies' Home Journal,* August 1896, 25. Rambler Bicycle ad: *Life,* June 13, 1895, n.p.; Marguerite Merington, "Woman and the Bicycle," *Scribner's Magazine* 17 (October 1895): 705.

28. Marjorie Garber, *Vested Interests: Cross-Dressing and Cultural Anxiety* (New York and London: Routledge, 1992), 288–295. For articles on Joan of Arc, see *Nineteenth-Century Readers' Guide to Periodical Literature, 1890–1899* (Gloucester, MA: Peter Smith, 1963), 1428–1449; Mark Twain, *Personal Recollections of Joan of Arc by the Sieur Louis de Conte (Her Page and Secretary)* (1895; rpt. New York: Gramercy Books, 1995), 5–7, 199, 116, 126, 237, 385. Contemporaries seemed aware of Twain's gender anxiety. In "Life's Horoscope," "Daisy" writes, "Samuel, L. (C–L–M–N–S). In personal appearance he is very short and has a rotund framework, nasturtium cheeks with inlaid eyes, feet with a double accent, a huckleberry walk. . . . He has an inordinate desire for dress and spends all of his time grooming himself. . . . He should . . . wear simple Mother Hubbards [a woman's dress]." *Life,* June 18, 1896, 495. Belle Boyd, a Confederate spy who dressed as a soldier, was called "the Rebel Joan of Arc." http://mariah.stonemarche.org/livhis/women/body.htm; Frances C. Lowell, *Joan of Arc* (Boston: Houghton Mif-

flin, 1896), 365. Mary Gordon notes that "Joan's page reports that she preferred sleeping beside young rather than old women." Mary Gordon, *Joan of Arc* (New York: Viking Book, 2000), 145. Isabel M. O'Reilly, "The Maid of Orleans and the New Womanhood," *American Catholic Quarterly Review* 19 (1894): 582–606. On the continuing interest in Joan of Arc, see Charles Maurice Stebbins, A.M., ed., *De Quincey's Joan of Arc and the English Mail-Coach* (Boston: D. C. Heath, 1907).

29. Mrs. E.D.E.N. Southworth, *Fair Play* (New York: F. M. Lupton Publishing, 1868); Mrs. E.D.E.N. Southworth, *How He Won Her* (Chicago: M. A. Donohue & Co., 1869); E.D.E.N. Southworth, *The Hidden Hand* (1888; rpt. New York: Oxford University Press, 1997).

30. Susan Koppelman, ed., *Two Friends and Other Nineteenth-Century Lesbian Stories by American Women Writers* (New York: Meridian, 1994), 33, 43–76, 99–123. Koppelman labeled Woolson's "Filipa" a "baby dyke" story. Ibid., 55. On Woolson and James, see Lyndall Gordon, *A Private Life of Henry James: Two Women and His Art* (New York: W. W. Norton, 1998); John Carlos Rowe, *The Other Henry James* (Durham, NC: Duke University Press, 1998).

31. On the aesthetic movement, see Mary Warner Blanchard, *Oscar Wilde's America: Counterculture in the Gilded Age* (New Haven: Yale University Press, 1998); Bettina Berch, *The Woman Behind the Lens: The Life and Work of Frances Benjamin Johnston, 1864–1952* (Charlottesville: University Press of Virginia, 2000), 101.

32. Berch, *The Woman Behind the Lens*, 10, 30–32.

33. Ibid., 38, 60. See artist Monika Rodgers's Web site and monika.rodgers @mailexcite.com: "Frances Benjamin Johnston, a lesbian, was a photojournalist." Hewitt's letters to Johnston include such declarations as "I love you, love you better than ever you know. . . . I slept in your place and on your pillow—it was most as good as the cigarette you lit and gave me all gooey." Hewitt "was Johnston's lover." Berch, *The Woman Behind the Lens*, 93, 145. On Victorian female relationships, see Carroll Smith-Rosenberg, *Disorderly Conduct: Visions of Gender in Victorian America* (New York: Oxford University Press, 1985). On a court case against same-sex sexuality, see Lillian Faderman, *Scotch Verdict: Miss Pirie and Miss Woods v. Dame Cumming Gordon* (New York: Columbia University Press, 1993). Faderman explores many professional women couples in Victorian

America in Faderman, *To Believe in Women*. On female couples in the New Thought Movement, see Beryl Satter, *Each Mind a Kingdom: American Women, Sexual Purity, and the New Thought Movement, 1875–1920* (Berkeley: University of California Press, 1999), 101–103. By the 1920s, women's friendships appeared pathological in America. John C. Spurlock and Cynthia A. Magistro, *New and Improved: The Transformation of American Women's Emotional Culture* (New York: New York University Press, 1998), 44–45. On lesbian artists, see Lisa Merrill, *When Romeo Was a Woman: Charlotte Cushman and Her Circle of Female Spectators* (Ann Arbor: University of Michigan Press, 1999), 256, 258; Ella McKinna, "The Recluse of Fontainebleau," *Ladies' Home Journal* 12:8 (June 1895): 7; Elizabeth Lapovsky Kennedy and Madeline D. Davis, *Boots of Leather, Slippers of Gold: The History of a Lesbian Community* (New York and London: Routledge, 1993), 5.

34. My material on Alice Austen comes from the following books: Ann Novotny, *Alice's World: The Life and Photography of an American Original; Alice Austen, 1866–1952* (Old Greenwich, CT: Chatham Press, 1976); Daile Kaplan, "The Wonderland of 'Clear Comfort': Photography and Art by Alice Austen," in *Fine Day*, exhibition catalogue (New York: Alice Austen House, 1988); Amy S. Khoudari, "Looking in the Shadows: The Life and Photography of Alice Austen" (M.A. thesis, Sarah Lawrence College, 1993); Emmanuel Cooper, *The Sexual Perspective: Homosexuality and Art in the Last 100 Years in the West* (1986; rpt. New York and London: Routledge, 1994); Susan Butler, "So How Do I Look? Women Before and Behind the Camera," in *Staging the Self: Self-Portrait Photography, 1840s–1980s* (London: National Portrait Gallery, 1987), 52–53. Maria E. Ward, *Bicycling for Ladies* (New York: Brentano's, 1896) has illustrations of bicycle repairs taken from Austen's photographs; http://www/geocities.com,/WestHollywood/Heights/9970/austenbio.html

35. Dijkstra, *Idols of Perversity*, 147–159; Khoudari, "Looking in the Shadows," 74–75.

36. Mark Twain drew on the female mirror image in *Eve's Diary* (1906). See Dijkstra, *Idols of Perversity*, 137.

37. Khoudari, "Looking in the Shadows," 49.

38. Novotny, *Alice's World*, 215.

NOTES ON THE CONTRIBUTORS

Mary W. Blanchard is an associate fellow and a member of the advisory board of the Rutgers Center for Historical Analysis. She is the author of *Oscar Wilde's America: Counterculture in the Gilded Age* (1998) and has written articles for the *American Historical Review,* the *Journal of American Studies,* and the *Journal of Women's History.*

Sarah Burns is Ruth N. Halls Professor of Fine Arts at Indiana University, Bloomington. She is the author of *Pastoral Inventions: Rural Life in Nineteenth-Century American Art and Culture* (1989), *Inventing the Modern Artist: Art and Culture in Gilded Age America* (1996), and *Painting the Dark Side: Art and the Gothic Imagination in Nineteenth-Century America* (2004).

Holly Pyne Connor is the Curator of Nineteenth-Century American Art at The Newark Museum. She has curated numerous exhibitions including *Town and Country: Images of Urban and Rural Life in America,* Shen Yang, China (1984), *Picturing America* (2001), and *American Art in the Dutch Tradition* (2001).

LIST OF LENDERS

Addison Gallery of American Art, Phillips Academy, Andover

Berry-Hill Galleries, New York

Bowdoin College Museum of Art

Brandywine River Museum

Brooklyn Museum

Canajoharie Library and Art Gallery

Victoria Daly

Delaware Art Museum

Fine Arts Museums of San Francisco

Historical Society of Pennsylvania, Atwater Kent Museum

Huntington Library, Art Collections, and Botanical Gardens

International Poster Center, New York

Library of Congress

Long Island Museum of American Art

Memphis Brooks Museum of Art

The Metropolitan Museum of Art

Mount Holyoke College Art Museum

Museum of Fine Arts, Boston

Nantucket Historical Association

National Academy of Design

Bill Nelson Collection

The Newark Museum

New Jersey Historical Society

The New-York Historical Society

New York Public Library, Schomburg Center
for Research in Black Culture

Ohio Historical Society

Pennsylvania Academy of the Fine Arts

Philadelphia Museum of Art

Princeton University Art Museum

Private Collections

Rhode Island School of Design Museum

Rutgers, The State University of New Jersey

Saint-Gaudens National Historic Site

Shelburne Museum

Catherine Smith

Staten Island Historical Society

Terra Foundation for the Arts

Virginia Steele Scott Gallery, Huntington Library,
Art Collections, and Botanical Gardens

Worcester Art Museum

TRUSTEES OF
THE NEWARK MUSEUM ASSOCIATION, 2005

PHOTOGRAPHY CREDITS

Figs. 1, 57, 66, 74, and 75: Photographs Library of Congress, Prints and Photographs Division LC-USZ62-76863, LC-USZ62-65804, LC-USZ62-74994, LC-USZ62-64301, and LC-USZ62-83111.

Fig. 2: Photograph © 1999 The Metropolitan Museum of Art.

Figs. 8, 15, and 42: Photographs © 2004 Museum of Fine Arts, Boston.

Fig. 21: Photograph © 1987 The Metropolitan Museum of Art.

Fig. 24: Photograph by Katherine Wetzel, © Virginia Museum of Fine Arts.

Fig. 25: Photograph © The Cleveland Museum of Art.

Figs. 28 and 30: Photographs © 1992 The Metropolitan Museum of Art.

Fig. 29: Photograph by Joseph Painter.

Figs. 31 and 50: Photographs © Sterling and Francine Clark Art Institute, Williamstown, Massachusetts.

Figs. 32 and 43: Photographs © The Art Institute of Chicago, All Rights Reserved.

INDEX

Gilman, Charlotte Perkins, xiii, 3, 65
Girl of the Period, 61–62, *62*, 63, 67, 133–134n8
Goldsmith, Barbara, 140n14
Goodyear, Sarah, 85
Gordon, Lyndall, 144n30
Gordon, Mary, 143–144n28
Grand, Sarah, 4
"Grecian Bend," 62, *63*
Greig, Cynthia, 125–126n1
Griffin, Randall, 136n26
gym suit, 95, *96*

Hale, Ellen Day, 25; *Self Portrait, 28, 29*
Hale, Sarah Josepha, 31, 130n42
Hamblin, Jessie DeFoliart, 141n19
Hamilton, Gail, 78
Hammond, William A., 141n19
Hardaker, M. A., 140n15
Harper's Bazar [magazine], 53, 58, *62, 63, 66,* 73, 80, *81*
Harper's Monthly [magazine], 87
Harper's Weekly [magazine], 8, *8, 59, 61, 67, 68, 79, 80, 106*
Harrison, Mrs. Burton, 138n3
Hearth and Home [magazine], 69
Henry, Edward Lamson: *Lucy Hooper in Her Living Room . . . ,* 29, *30,* 130n41; *The New Woman, 37–39, 38*
Hewitt, Mattie Edwards, 117, 144–145n33
Hills, Patricia, 127n15
Hirshler, Erica E., 125–126n1
Hodgers, Jennie, 103–104
Hoffman, Nancy, 136n26
Holt, Monroe, *83,* 89
Homer, Winslow, 8, 12, 20, 35, 129n34, 130–131n47, 136n26; "At the Spring: Saratoga" [wood engraving], 67, *69; Beaver Mountain, Adirondacks . . . ,* 87–89, *88; The Bridle Path, White Mountains,* 54, *56,* 57, 61, 74, 133nn3, 6; *The Country School, 75,* 75–76, 78–79, 80–81, 83; *Croquet Scene,* 68–69, 71, *71; Eagle Head, Manchester, Massachusetts . . . ,* 54, *55,* 64; *In the Mountains, 82,* 83–84, 86, 89–90; *Long Branch, New Jersey,* 67–68, *70; Manners and Customs of the Seaside,* 54; "May-Day in the Country" [wood engraving], 59, *61;* "The Morning Walk—Young Ladies' School . . ." [wood engraving], 66, *68; Mount Washington,* 57, *58,* 59, 60; "The Noon

Recess" [wood engraving], *79,* 79–80; *The Nurse,* 136n30; *Nurse and Child,* 136–137n30; "On the Beach at Long Branch—The Children's Hour" [wood engraving], 136–137n30; "Opening Day in New York" [wood engraving], 65–66, *66;* "Our Watering Places—The Empty Sleeve at Newport" [wood engraving], *8,* 8–9; "The Picnic Excursion" [wood engraving], 71–73, *72; Prisoners from the Front,* 54; "The Summit of Mount Washington" [wood engraving], 57–58, *59,* 59–61; *Sunday Morning in Virginia,* 20, *21,* 129n32, 137n34; *The Two Guides, 83, 84,* 89; *A Visit from the Old Mistress,* 137n34; *The White Mountains (see The Bridle Path, White Mountains);* "'Winter'—A Skating Scene" [wood engraving], 66, *67*
Hooper, Lucy, 29, *30*
hotels, 85
Howells, William Dean, 6, 24; *The Coast of Bohemia,* 24; *A Hazard of New Fortunes,* 25
Hubert, Philip G., Jr., 143n26
Hughes, C. H., 141n20
Hunter, Jane H., 65, 142n25

intellect, female, 25

Jackson, Kenneth T., 130n41
James, Henry, 6, 116; *The Bostonians,* 12; *Daisy Miller,* 4, 17; *What Maisie Knew,* 3
Joan of Arc, 115–116, 143–144n28
Johns, Elizabeth, 132–133n2
Johnson, Eastman: *The Hatch Family, 7, 7; Interesting News,* 19–20
Johnston, Frances Benjamin, 117–120, *118, 119;* "The Negro Exhibit" [photography show], 120
Jordanova, Ludmilla, 141n19

Kaplan, Daile, 145n34
Kasson, John, 128n19
Katz, Jonathan, 141n20
Kellogg, Clara Louise, 139n8
Kelly, Libby, 114
Kidwell, Peggy, 137n32
Kennedy, Elizabeth Lapovsky, 144–145n33
Khoudari, Amy S., 145n34
Kilmurray, Elaine, 132n58
Kitch, Carolyn, 126n3, 142n25
Kushner, Marilyn S., 127n16

photographic, *107, 118, 119, 121, 122, 123. See also* family portrait; self-portraits

posters, 39

prejudices, 33

professional women, 25, 33, 40; relationships, 144–145n33

Puck [magazine], *34*, 97

reading, 17, *18,* 19–21, 129n29

"Real Womanhood," 73

resorts, 85

Ressler, Susan R., 125–126n1

Revolution [magazine], 53

Richards, T. Addison, "Ascent of Mount Marcy," 86, *87*

riding. *See* bicycling; equestriennes

Roosevelt, J. West, 143n26

Rosenberg, Rosalind, 126n5

Rourke, Constance, 140n17

Rowe, John Carlos, 144n30

rowing, 113

Rury, John L., 136n23

Ryan, Mary P., 128n19

Sachant, Pamela, 135n20

Sargent, John Singer: *Mr. and Mrs. Isaac Newton Phelps Stokes,* 43, 46, *48; Mrs. Charles Thursby,* xi, 43, 46, *47; Portrait of Miss Carey Thomas . . . ,* 46, 49, *50*

Satter, Beryl, 144–145n33

"savage woman," images of, 138n1

Schaffer, Talia, 141n19

Schiller, Joyce K., 125–126n1

Schlissel, Lillian, 139n5

Scholnick, Robert J., 135n18

schools, 65, 76–81, 83. *See also* women's colleges

schoolteachers, 75–81, 83, 136n26

Schreier, Barbara A., 133n7

Scobey, David, 134–135n13

Scribner's Magazine, 5, 21, *22*

Segard, Achille, 128n23

self-portraits, 25–29, *26, 27, 28,* 116–117, *118, 119, 121, 122, 123,* 130n40

Severa, Joan L., 137n31

sexual perversion, 110

Shackelford, George T. M., 125–126n1

Sharp, Kevin, 125–126n1

Sherry, Karen A., 132–133n2

shirtwaist, 4, 46

Showalter, Elaine, 140–141n18

Sklar, Kathryn Kish, 136n23

Slater, Lucy Ann, 110

Smith, Catherine, 125–126n1

Smith, H. Perry, *Modern Babes in the Wood, 85*

Smith-Rosenberg, Carroll, 125–126n1, 133n3

social Darwinism, 33

social norms, challenged, 122

soldiers: female, 100–105; in fiction, 115

Sorosis Club, 53

Southworth, Mrs. E.D.E.N., *How He Won Her* and *The Hidden Hand,* 116

Spassky, Natalie, 127n15

Spencer, Herbert, 33

Spencer, Lilly Martin, xiii, 8; *The War Spirit at Home,* 9–10, *10,* 11–12, 127–128n18

Spong, Hilda, 40, *42*

sports, 35–39, 112–114. *See also* athletics; bicycling; boxing; croquet; equestriennes; rowing; tennis; walking feats; wilderness sports

Spurlock, John C., 144–145n33

Stanton, Elizabeth Cady, xiii, 2, 100

Steele, Valerie, 138–139n5

Stephens, Alice Barber: *The Woman in Business,* 129–130n37; *The Women's Life Class,* 23–24, *24*

stereotypes, challenged, 116, 122

Stewart, Hattie, 114

Stokes, Edith, 43, 46, 48

Stowe, Harriet Beecher, xiii; *Little Pussy Willow,* 64, 135n15

Strang, James Jesse, 99

Stratis, Harriet K., 125–126n1

suffrage movement, 132n1

Swinth, Kirsten, 23

Tatham, David, 86, 133n3, 137n33

teachers, female, 75–81, 83, 136n26

tennis, 35, *36*

Tepe, Mary, 101–102, *102*

thinking women, 17–23, 43

Thomas, M. Carey, 46, 49, *50*

Thursby, Alice, 43, 46, *47*

Todd, Ellen Wiley, 125–126n1, 132n59

tourism, 84–90

traditional values, 73

travel narratives, 84–85

trousers. *See* pants